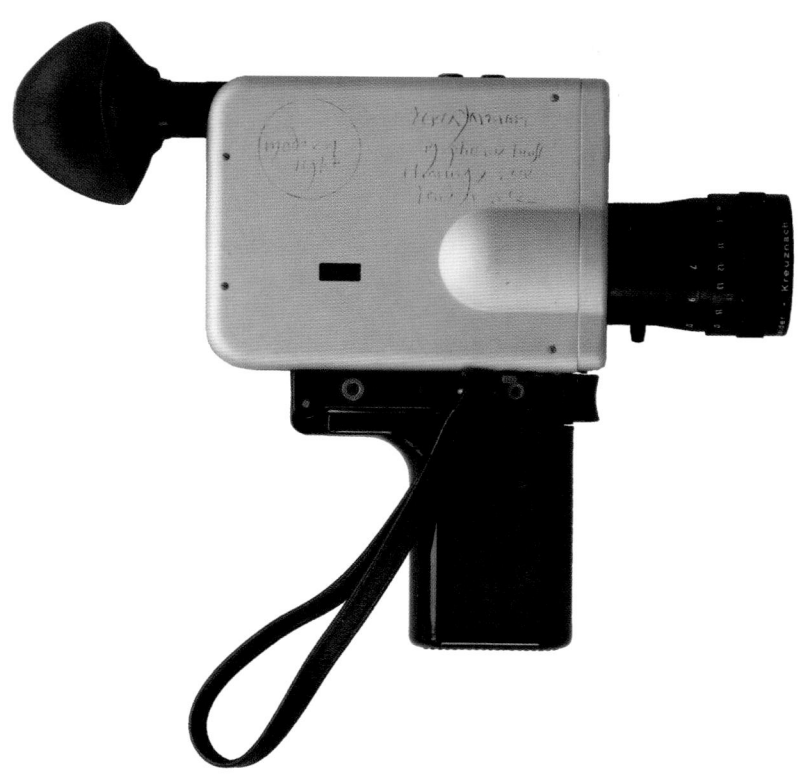

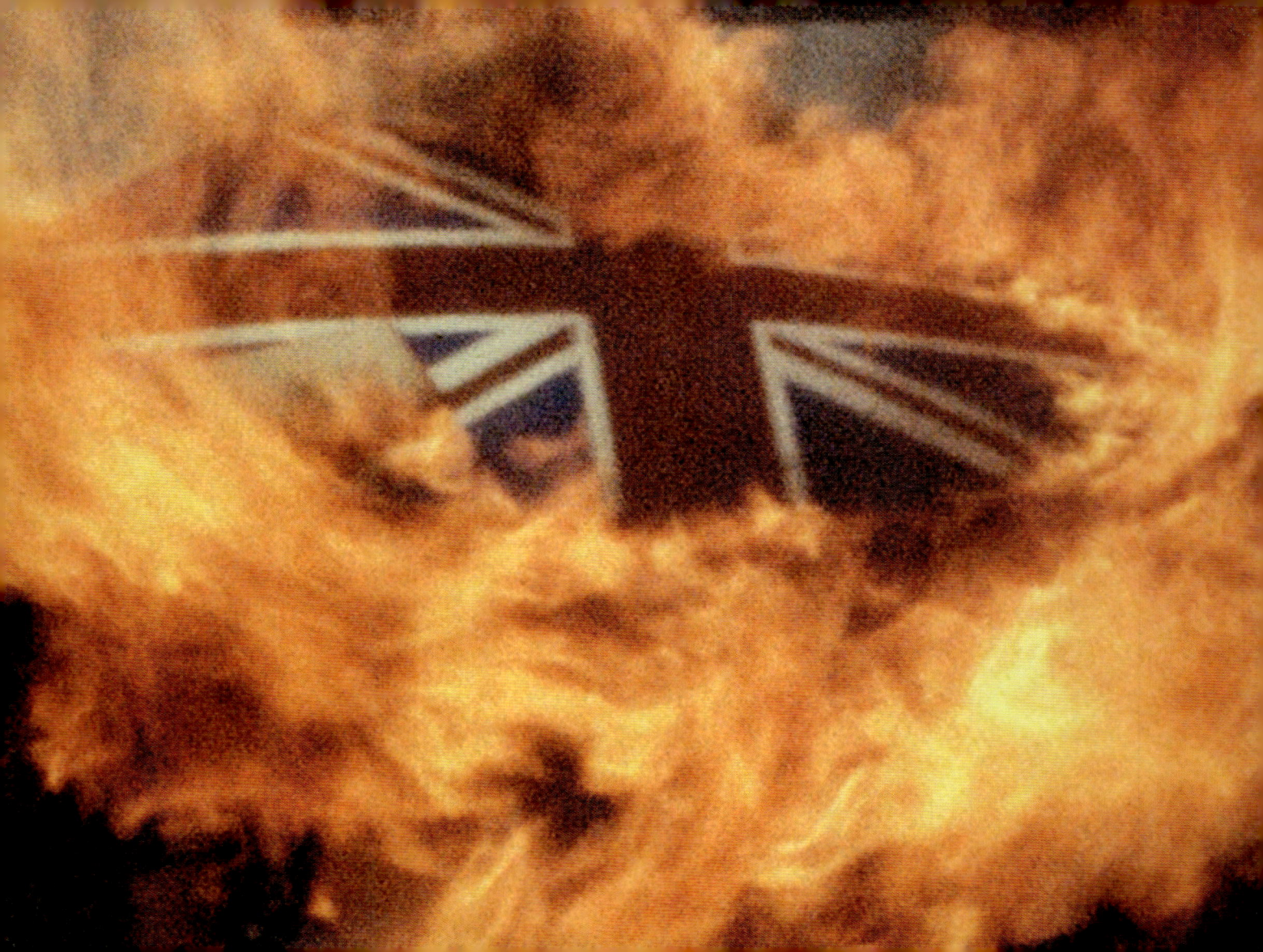

DEREK JARMAN
SUPER 8

JAMES MACKAY

With 780 illustrations

 Thames & Hudson

 LUMA FOUNDATION

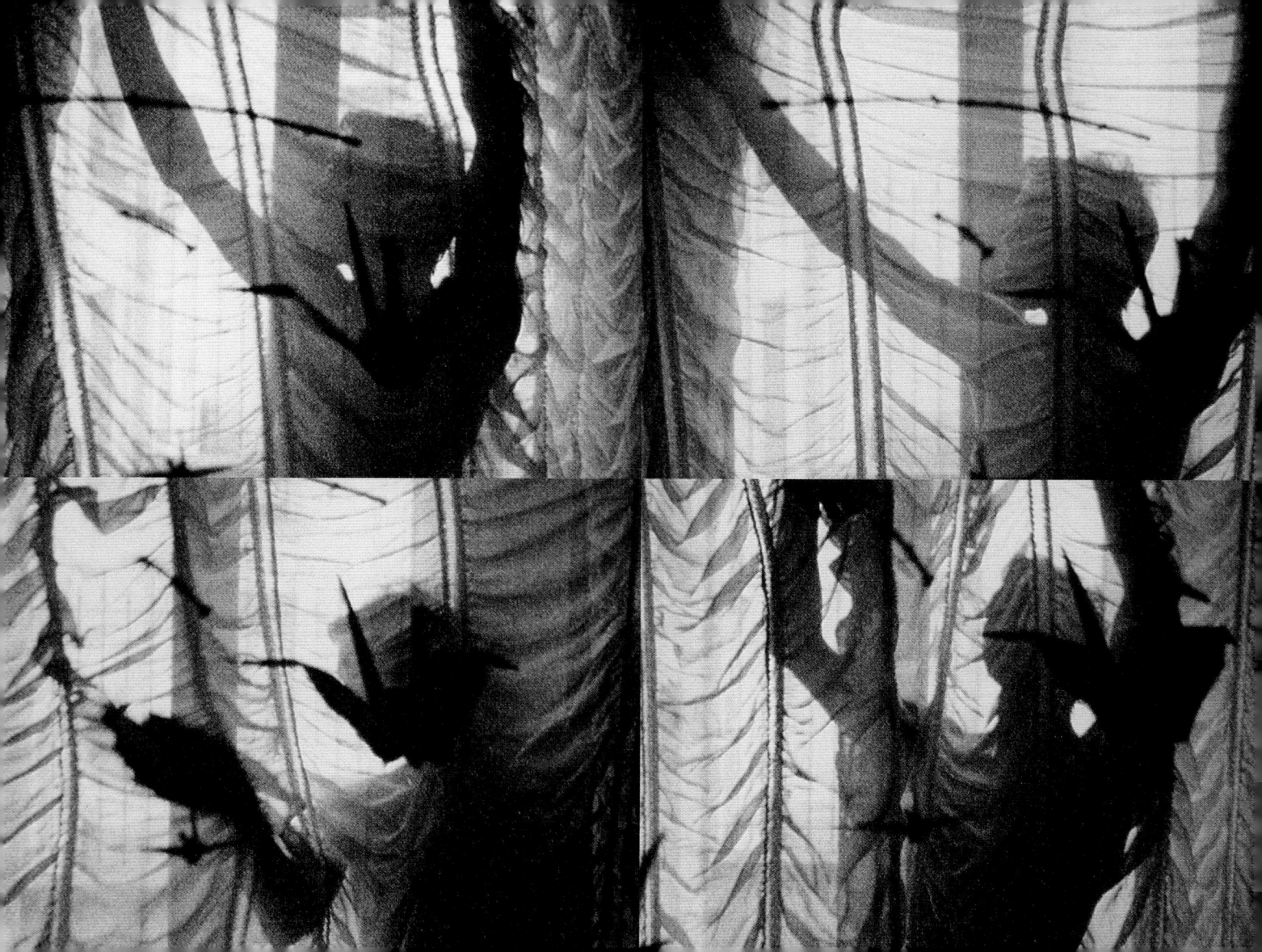

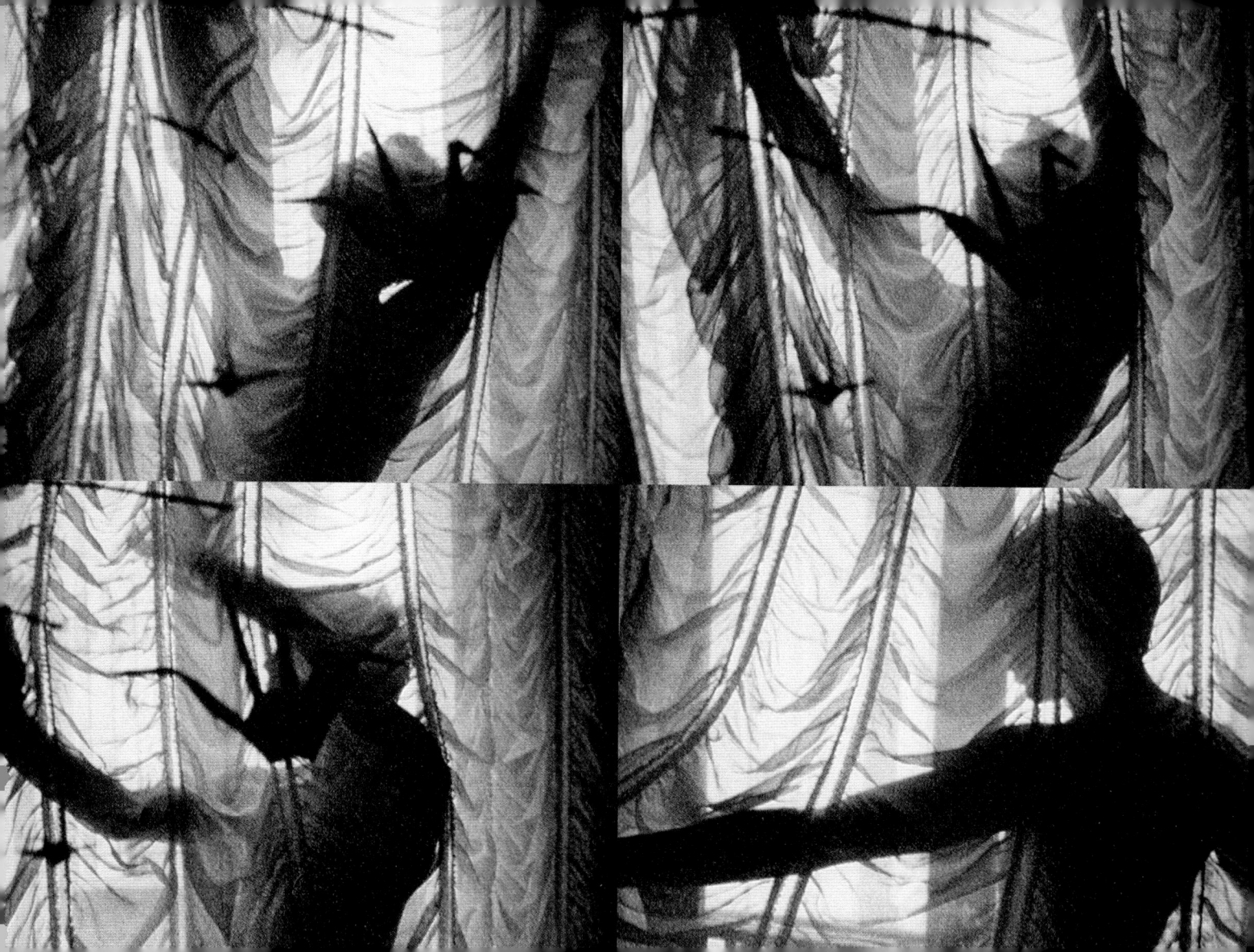

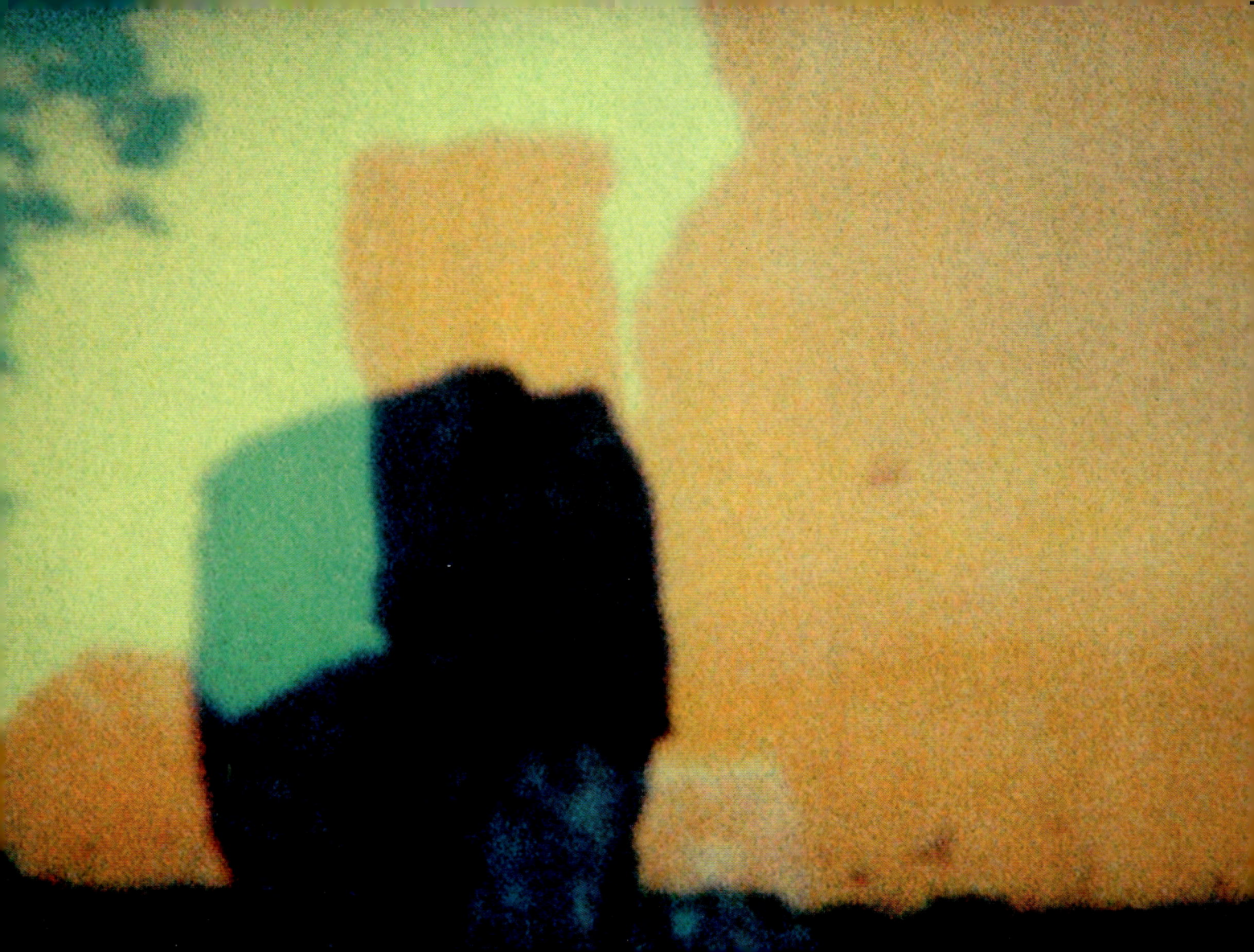

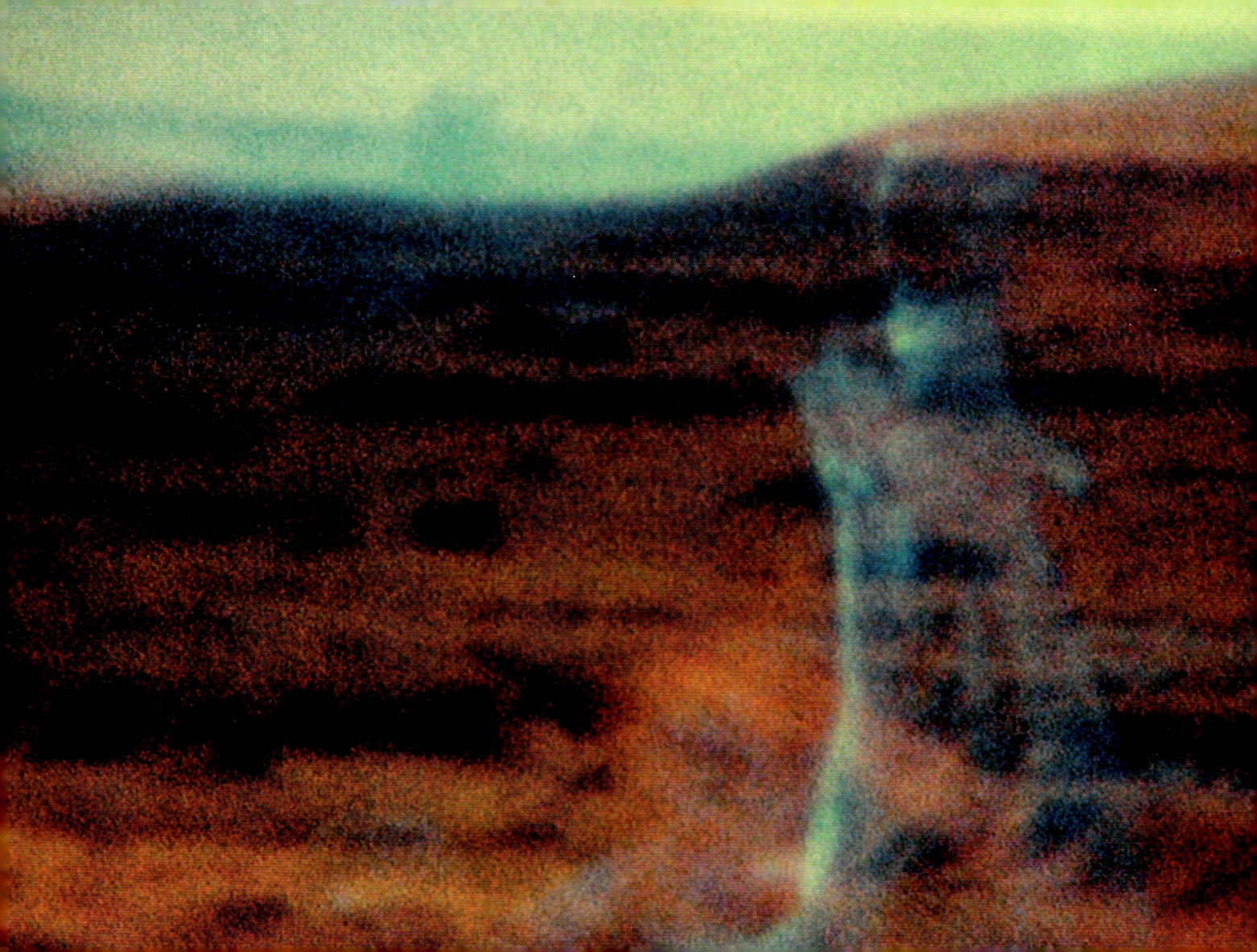

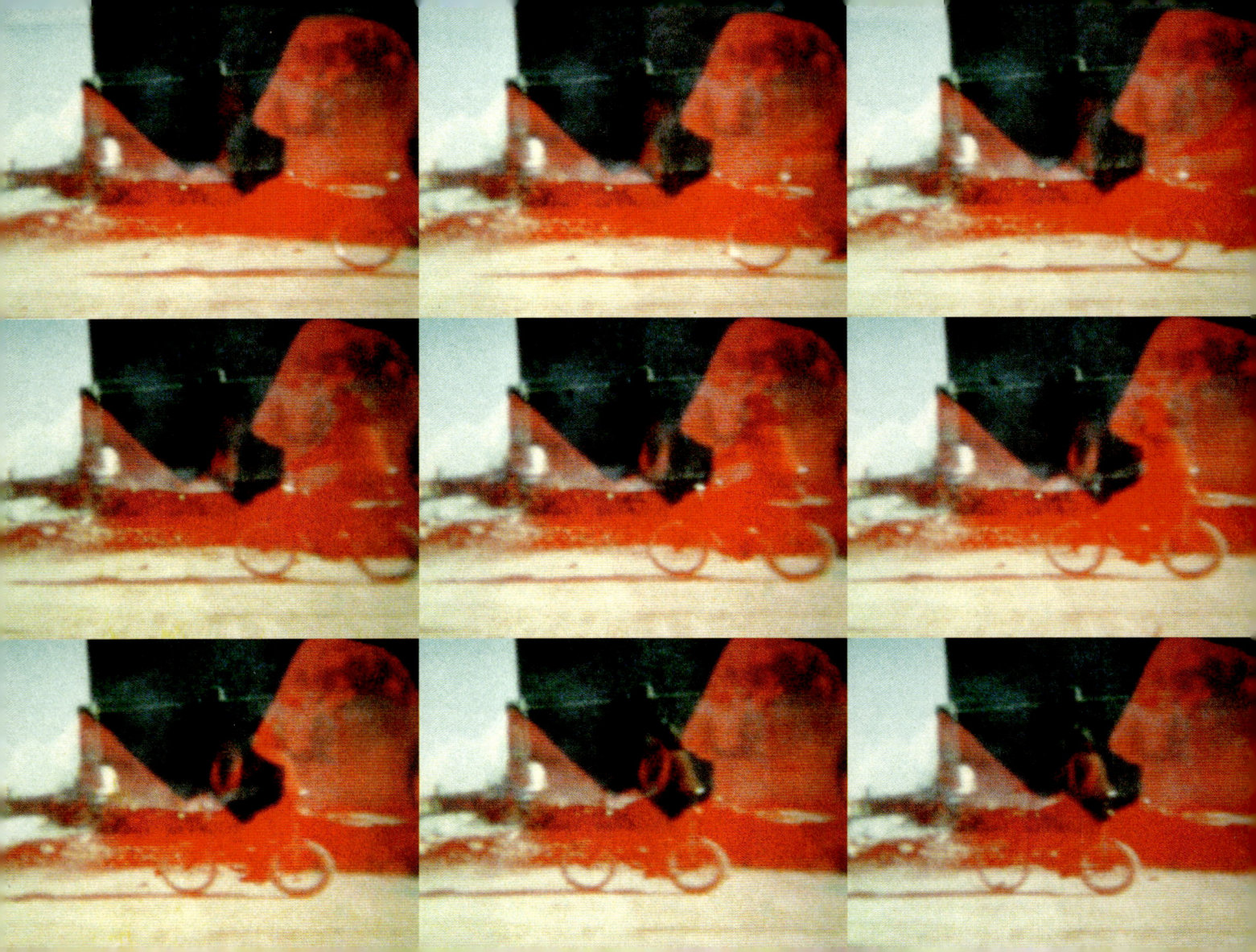

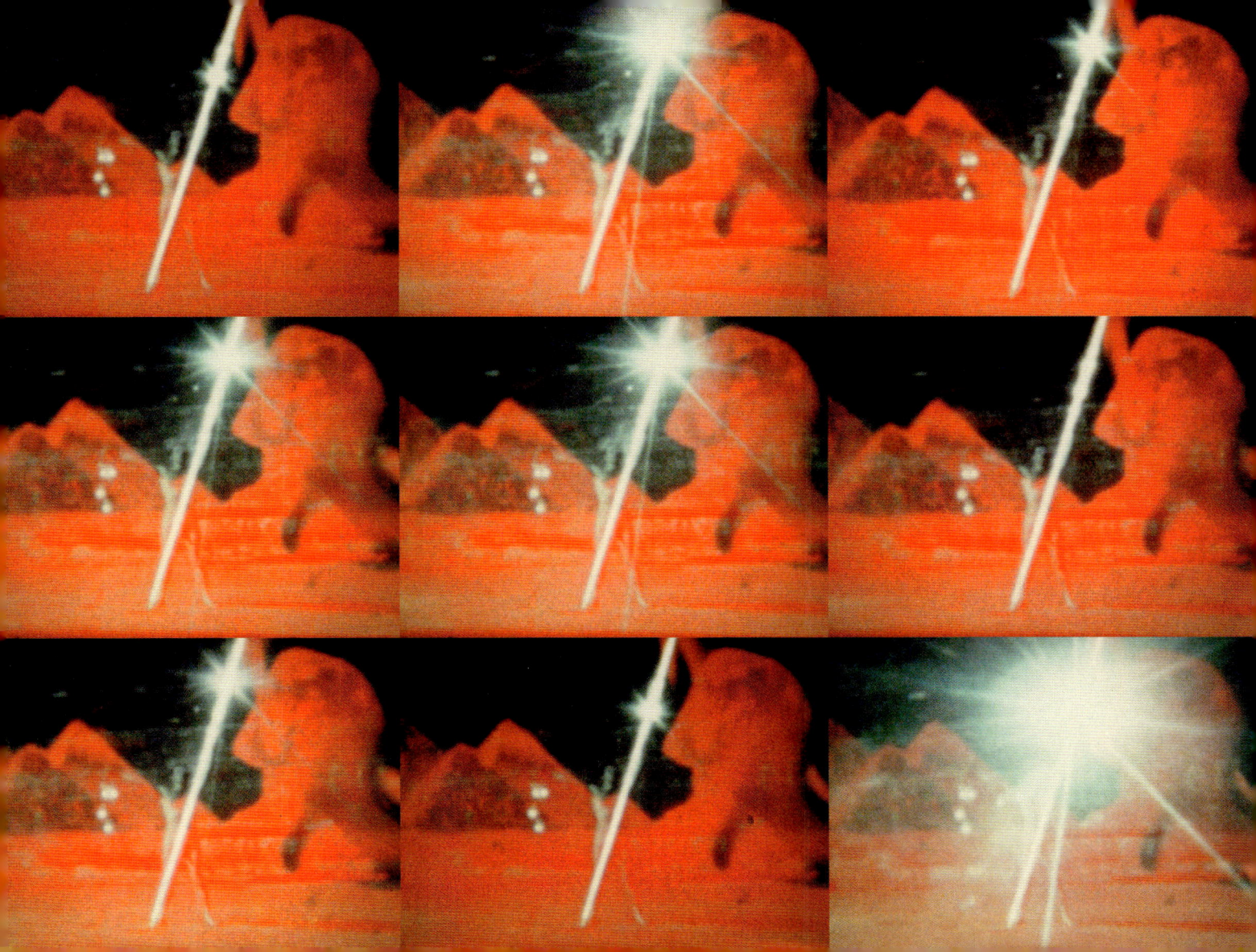

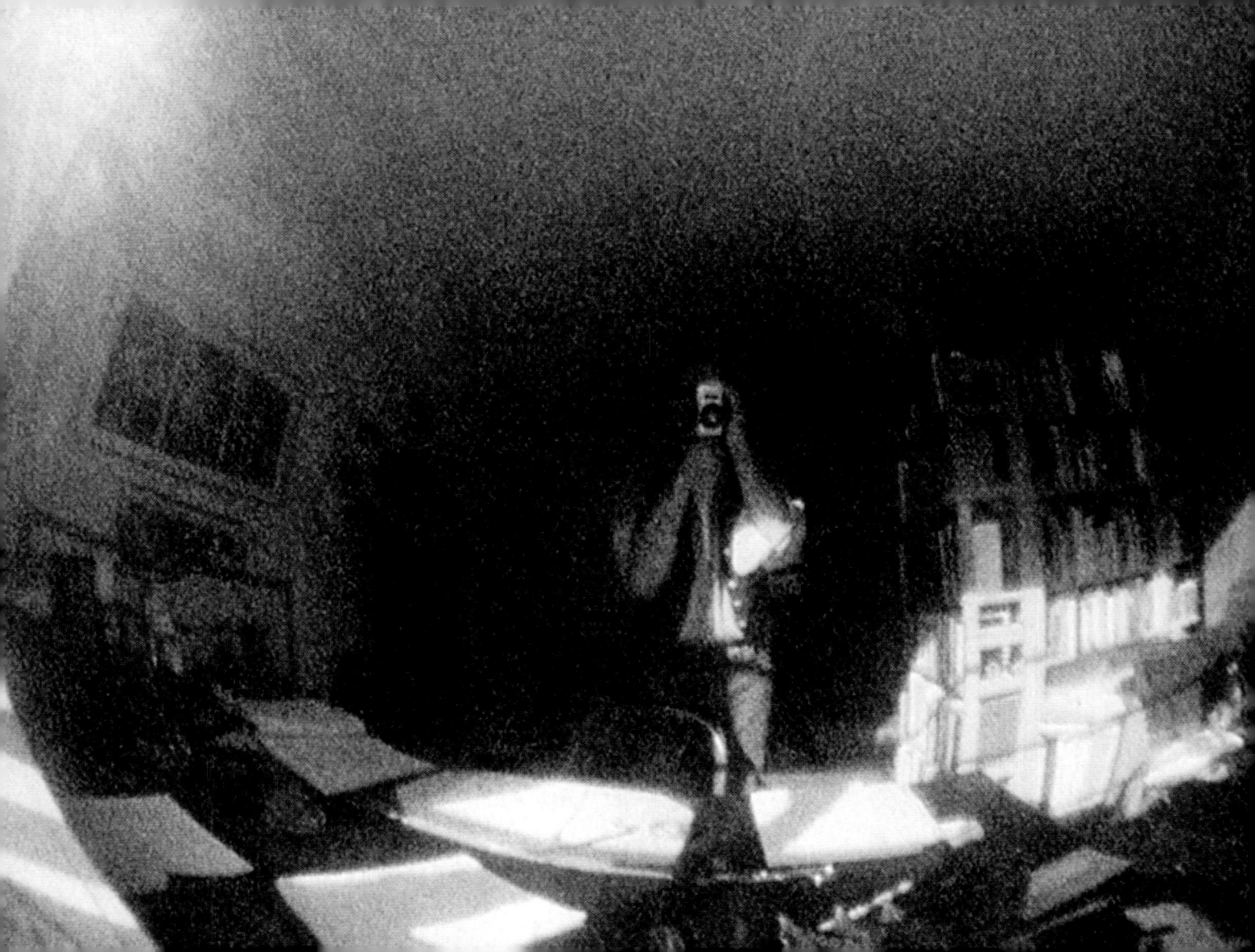

CONTENTS

13 PREFACE
 Maja Hoffmann

14 AN INTRODUCTION TO DEREK JARMAN'S SUPER 8MM FILMS
 Beatrix Ruf *in conversation with* James Mackay

22 SLNC IS GLDN
 James Mackay

38 #1 | ADOLESCENCE: Stolen at the Point of Obsolescence
 Liam Gillick
42 *At Low Tide* 1972

48 #2 | DIARY FILMS: 'Music Videos' for Beginners
 Wilhelm Sasnal
52 *Studio Bankside* 1972
68 *Andrew Logan Kisses the Glitterati* 1973
70 *Stolen Apples for Karen Blixen* 1973
74 *Tarot* 1973

82 #3 | HAPPY ACCIDENTS: Sketchbook Filming
 Sarah Turner
86 *Garden of Luxor* 1973
98 *Death Dance* 1973
104 *Sulphur* 1973

112 #4 | A FRIEND INDEED: The Colourful Past
 Gina Birch
116 *Journey to Avebury* 1973
122 *Ashden's Walk on Møn* 1973
128 *Duggie Fields at Home* 1974
134 *My Very Beautiful Movie* 1974

142 #5 | MAGIC & LOSS: Selective Blindness & Analogue Reality
 Matthias Müller
148 *In the Shadow of the Sun* 1972–74
154 *Sloane Square: A Room of One's Own* 1974–76
162 *Corfe Film* 1975

172 #6 | BEYOND LANGUAGE: At The Seams of Seduction
 Peter Fillingham
178 *Sebastian Wrap* 1975
184 *Gerald's Film* 1975

188 #7 | JORDAN'S DANCE: The Transmutation of Elements
 Neil Bartlett
192 *Jordan's Dance* 1977
196 *Art & The Pose* 1977
202 *B2 Movie* 1981
216 *Waiting for Waiting for Godot* 1982
220 *Pirate Tape* 1982
224 *ICA* 1982

232 #8 | PICTURING DISSENT: Queer Experiments
 Isaac Julien
238 *It Happened by Chance* 1972–83

274 ANGELIC CONSERVATION: A Technical Overview of Archiving & Restoration
 James Mackay & Tom Russell

282 FILMOGRAPHY

286 INDEX

288 ACKNOWLEDGMENTS & PICTURE CREDITS

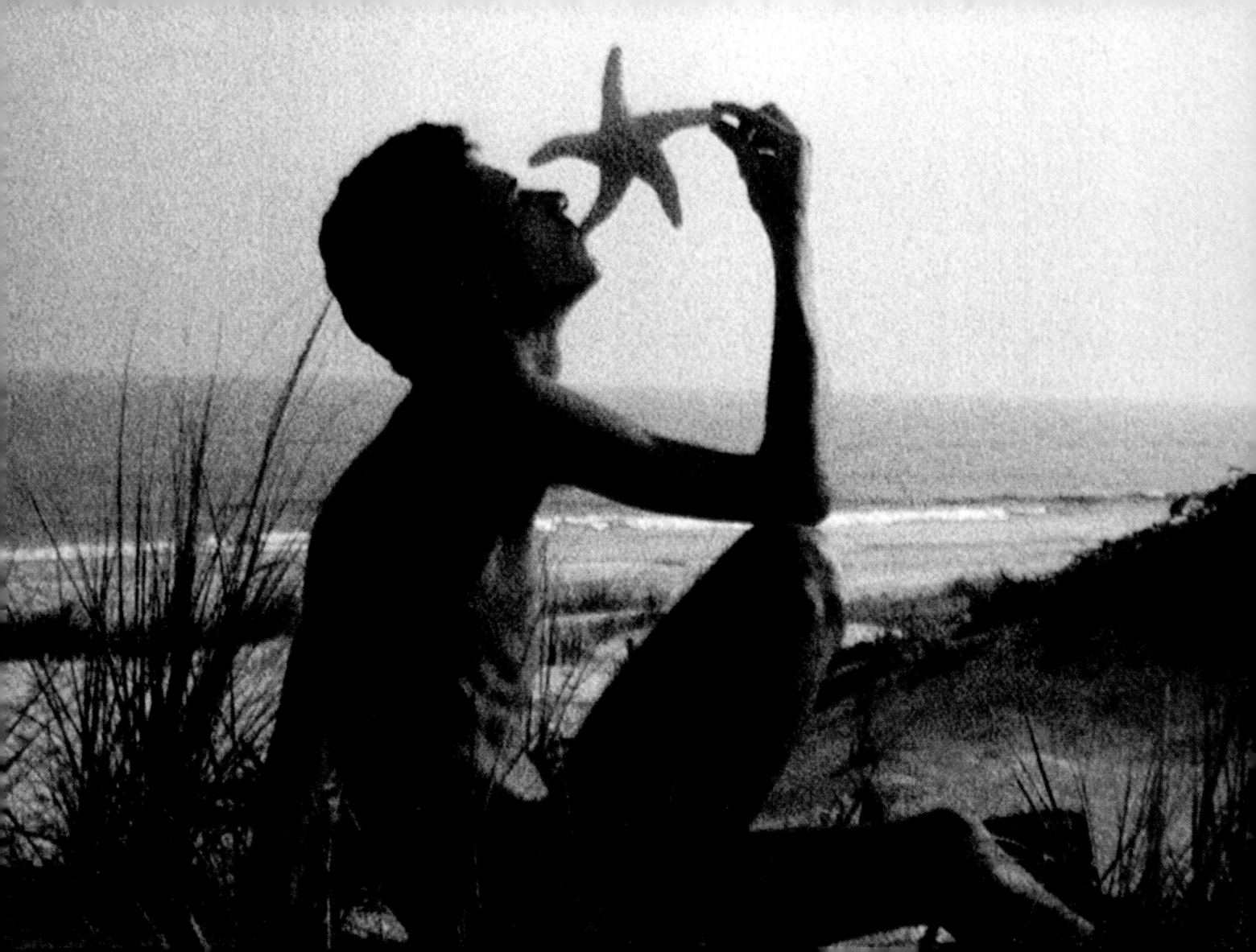

PREFACE

MAJA HOFFMANN
Founder, LUMA Foundation

opposite **Fire Island beach in My Very Beautiful Movie (1974).**

I established the LUMA Foundation in 2004, with the purpose of supporting the work of independent contemporary artists and bringing it to a wider public.

When I first saw Derek Jarman's Super 8 work, in 2008, at an exhibition curated by Isaac Julien at London's Serpentine Gallery, I was immediately engaged. Hans Ulrich Obrist, Beatrix Ruf and James Mackay told me that many of the films were in danger of fading away, so I was pleased to be able to pledge LUMA's support to safeguard the work for the future.

James instigated a conservation programme for the Super 8s, to produce an archive of high-quality digital copies that will become part of the core collection at our new centre in Arles, France.

I never met Derek, but I realize what a deeply creative man he was, and how he crafted works of a range and beauty that belie a medium intended for simple domestic use. His work ranged from film to painting, stage design to writing, poetry to gardening.

Derek's Super 8s often relate closely to his paintings of the time and include transposed images from other media. Some of the films, such as the *Art of Mirrors* series, encompass various forms with elaborate costumes, fire mazes, multiple superimpositions and coloured filters. Intimate portraits of friends and lovers are filmed in his trademark stepping slow motion style, and he also kept a series of 'diary' films made from interesting odds and ends.

It is a great pleasure to collaborate with Thames & Hudson, turning the beautiful and haunting images into this excellent book which, I feel, gives an authentic flavour of the films themselves and of Derek Jarman, a truly independent artist.

AN INTRODUCTION TO DEREK JARMAN'S SUPER 8MM FILMS

BEATRIX RUF, Director Stedelijk Museum, Amsterdam, in conversation with JAMES MACKAY

opposite left **Jarman's Super 8, 'Modern Light', a Nizo 560.**

opposite right **Jarman's Super 8, 'Night Light', a Nizo 480.**

BEATRIX RUF *Looking through the book and at the exhibitions Isaac Julien curated for the Serpentine Gallery, Kunsthalle Zürich and Kunsthalle Wien, I am intrigued by the way Super 8 films can be shown and represented. I am also very much reminded of Dieter Roth's* Solo Scenes, *a 128-monitor piece in which he puts a diary of his life on display. You can see all of Derek's Super 8 films as one ongoing image, so to speak — as a flood of images that are all connected, even if they are considered individual films.*

JAMES MACKAY Yes, that aspect is particularly obvious in the series of films he used to create *In the Shadow of the Sun*, which incorporates about a dozen different films. Other things that highlight their interconnectedness are his themes, and the images of people who crop up from film to film.

BR *Julien presented* It Happened by Chance *in a ten-screen version. What do you think of its translation into an exhibition context?*

JM I'm always interested to see how curators interpret work. It wasn't the first time that the work had been shown as a multiple-screen projection. It had been done that way when Derek was alive, though only with a few screens. So Isaac took it a bit further. But it worked for me. I suppose he wanted to show how much work there was — a kind of galaxy of films, as he called it.

BR *I remember that, for the Zurich show, we tried to re-create that improvisational character by giving CD players to the audience containing tracks Derek used for his Super 8 screenings.*

JM That's right. He'd just pick a film out of his bag and put it on, and at the same time he would choose a piece of music to play along with it. What interests me is when the moving image became part of the art world rather than the world of cinema. The history of video is actually very short. When I left college

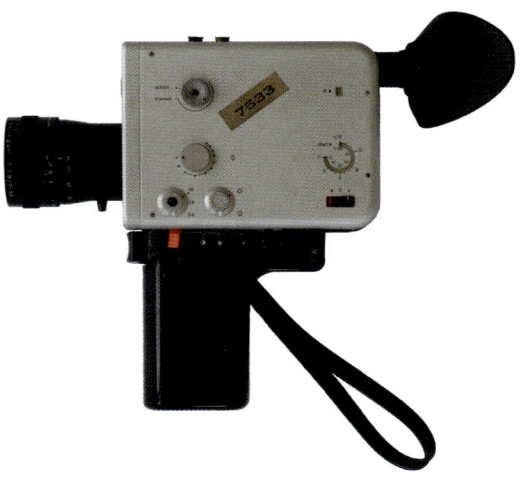 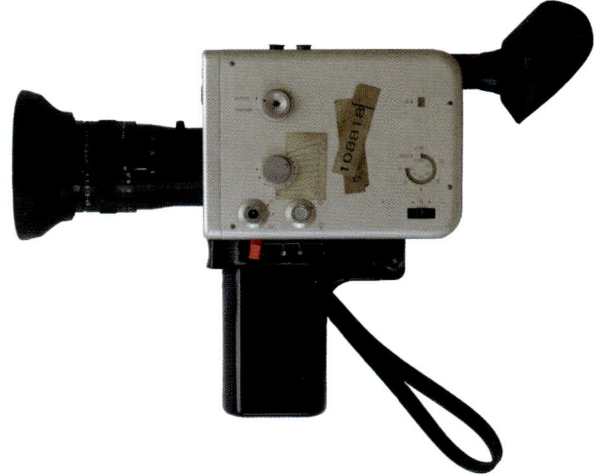

in the 1970s video art and film were distinct. You rarely saw video art in galleries, it wasn't seen as being relevant or important, but now it's rare to go to a show by a contemporary artist without seeing the moving image.

BR *You think it was not accepted as an art form?*

JM I think there was a kind of exclusion of the moving image from serious art. You could be a painter, a sculptor in a gallery context, but you couldn't be a filmmaker in a gallery context. When Derek, who was an exhibiting artist, moved to film, his art practice was excluded from the art world. He found it very difficult to get shows at all.

BR *As far as I know, many of the screenings happened in his studio.*

JM That's right. Derek presented his films in venues such as the ICA, but a lot of the time he just used his studio, showing them to informal gatherings. That was his personal way of working. When he made the films, he collaborated with people who sometimes didn't realize that they were engaged in creating something serious, because he would make the process so entertaining.

BR *They're also an expression of a very particular time in London.*

JM Derek came out of the counter-culture of the 1960s. And for some reason — perhaps because of post-war childhood austerity — money just didn't enter into it.

BR *Obviously there was a different type of image production in experimental film at that time — the structuralist experimental filmmakers, for example.*

JM Yes. There was a very active movement in the London Filmmakers' Co-Operative: Malcolm Le Grice, Peter Gidal, Lis Rhodes were some of the really important filmmakers

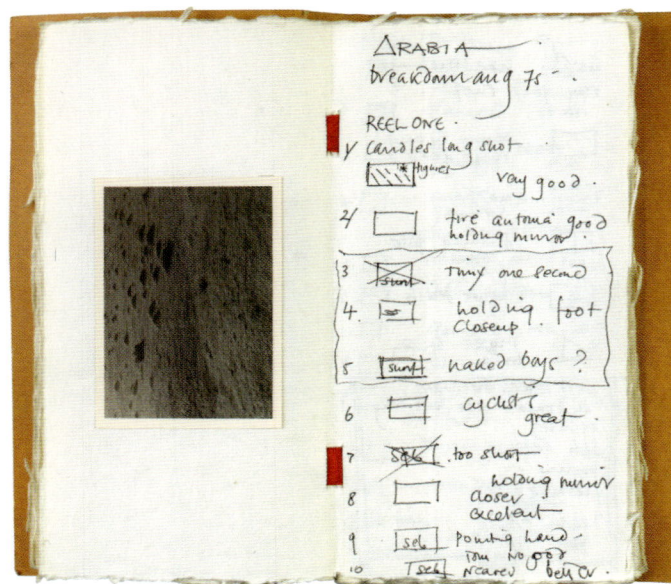

Jarman's 'Made in Egypt' sketchbook (1975) containing a photograph of the terrain at Møn, taken during the filming of *Ashden's Walk on Møn* (1973), alongside Super 8 notes filming notes.

who emerged at that time. Derek, and others, such as Jeff Keen and John Latham, worked outside that structuralist group. It's interesting that Derek's father and grandfather were enthusiastic filmmakers: his childhood is very well documented in 16mm, but Derek didn't actually make a film until 1970. He did, of course, work with Ken Russell on two films, one of which, *The Devils*, was a major Hollywood-sized production with a big budget.

Maybe Derek's Super 8 filmmaking was a reaction against these industrial feature films. He found the enforced discipline quite hard. He told me a story about how he designed the set of *The Devils*, building a model in polystyrene. When he presented it at a studio meeting they decided that they couldn't build anything that big, even though they had a budget of a million pounds. It would have to be smaller, so one of the studio executives took a bread knife, cut his set up into smaller pieces and joined it back together. Derek found those non-aesthetic decisions quite frustrating.

BR *In the commercial film world?*

JM Definitely. He had a similar experience in the theatre world. For the last ballet that he designed, *Silver Apples of the Moon*, he had the dancers wear flesh-coloured costumes and it was cancelled because they said it was pornographic. At that point he seemed to retreat from a large group of friends into a much smaller social circle, people who were maybe on the fringe of the London social scene, outsiders. And that's when he started making the Super 8 films. When I worked with him much later, his films were extremely organized. It wasn't just, 'Oh, let's make a film': he really planned it. He would check and recheck the equipment every day before we started filming, to make sure that everything was working properly. When he started work, he'd lose all the boring bits when you have to repeat things and everybody shouts 'silence, silence'. He created this social way of making films. On one level they're very serious, and on another level they're a lot of fun, both to watch and to make. I wonder whether this

sense of playfulness led him to be taken less seriously than he should have been.

BR *You said that he was very professional in his approach and that the Super 8s were not only about experimentation. Were they a kind of ongoing sketchbook?*

JM In one sense, yes, because he was free to experiment, and quite clearly he learnt from film to film. In another way, no, since the effort he invested made many of them far more than mere sketches. Some are constructed from many superimposed layers, achieved over time as each layer is filmed, refilmed and filmed again. And he considered *In the Shadow of the Sun* to be just as important as any of the feature films that he made in the 1970s: *Sebastiane*, *Jubilee* or *The Tempest*. He couldn't understand why the critics didn't see them as being of equal worth. He was genuinely baffled. Much later on, when he was making *Edward II*, he told me that he thought he'd got the balance right and had brought 35mm closer to the Super 8 way of working. He was always conscious about the two different types of filmmaking. And he was always trying to imbue 35mm with the flexibility and ideas of Super 8.

BR *Quite a few of the Super 8s were transferred to 16mm, and you were involved with that.*

JM A few, in the early 1980s. With the help of the Berlin Film Festival we transferred *In the Shadow of the Sun* to 16mm. We also had four other films blown up from Super 8 to 16mm. At the time I met Derek, he'd already curtailed showing the original Super 8s because they were getting worn and he was scared they would be damaged. That's why we raised the money: to have them blown up to 16mm so that he could show them but preserve the originals.

Derek was really proud of his Super 8 work. It was very important to him. He told me he put as much of himself into a film like *In the Shadow of the Sun* as he did into *The Tempest*.

BR *Was he interested in showing them in an art context or as this 'stream of images' we talked about earlier?*

JM Both, really. I've just remembered that in the second year I knew Derek, he arranged for the Super 8s to be screened at an art fair at the Barbican, London. This was 1981. I went along, and Derek had arranged for a booth like they have at art fairs, equipped with a tape player and monitor. I had a video copy of *In the Shadow of the Sun*, and I showed the film. And nobody was interested! Derek didn't come, of course.

BR *Did you stop screening the 1970s Super 8s?*

JM Yes, Derek's last real screenings were in 1979–80. To transfer them to 16mm would have been very expensive, and we were both really broke. Derek was living a fairly hand-to-mouth existence then because making a feature film in the 1970s didn't pay very much. Cans of soup. Most people were broke. But as we got into the 1980s Olympus brought out a Portapak, a VHS camera. Derek managed to persuade them to lend him one. And so he started to use that to transfer films to video.

BR *By refilming Super 8s projected on the wall?*

JM On a sheet of white card taped to the wall. We spent three days in 1982 at the ICA, refilming some of Derek's Super 8s onto video using that camera. On the second day we got bored and started filming other things. Derek projected films onto the guy who was helping us and refilmed them with the camera; that

ended up as the central part of *Angelic Conversation*, the guy holding the mirror. Then, when Derek returned from a Russian tour, we used the resulting black-and-white Super 8 footage to make *Imagining October*. Once finished, those two films were shown in Berlin, and Dagmar Benke from ZDF, the German broadcaster, approached us and said she'd like to fund a film, so we made *The Last of England*. At that point we forgot about transferring the Super 8s and concentrated on making new films.

BR *But he was making Super 8s the whole time, yes?*

JM He made and edited Super 8s up until 1982, 1983. After that, they're all part of something else: shorts, features, music promos. They're not standalone films edited to be Super 8 films.

BR *And he never continued that attitude of experimentation and filming as a sketchbook with video?*

JM Yes, he did. I have some videotapes, two of which are transferred to DigiBeta, and some others in a box that I haven't played because I'm worried they'll get damaged. The two films that I've seen are just continuous takes: they're rather good, actually, they're fun. He doesn't film in the same way that he filmed with Super 8, because he's using sound and talking to people.

BR *You mentioned once that* Glitterbug *was supposed to be the image-loaded counterpart to* Blue.

JM You're right. He discussed it with me first in 1987, around the time we were finishing *The Last of England*. Already he was talking about two films: *Blue*, and a companion piece made of images from his Super 8s. However, by the time we got to the end of *Blue* he was very ill. Nigel Finch and the BBC stepped in very kindly and gave Derek a slot on *Arena*, the arts programme, to make a compilation of his Super 8s. It had to be 54 minutes, so it's much shorter than *Blue*. Transferring so much quickly to video was very difficult, so we concentrated on the more documentary aspects of the Super 8 work, the recordings of people and places. It wasn't really quite the film he intended as a companion piece to *Blue*.

BR *I understand that he was very sick then, and almost couldn't see any more.*

JM He was very visually impaired and his health wavered. The great thing about Telecine, about the professional copying of film to video, is that you view it on a very bright screen, so he was able to see the images quite clearly. He could completely recall every single frame of film. As we went through the transfer he would tell us where and when it was filmed, who was in it, which images were coming up next. If you think about it, there were 82 films, plus the diary films — that's a lot to remember. He had a remarkably strong visual memory, Derek.

BR *So* Glitterbug *marked the beginning of your work with the archive?*

JM Yes. It was constrained by a small TV budget, but it was the beginning of the archiving process. We looked at quite a lot of the Super 8 material, but not all of it. There was too much.

BR *What was Derek's intention in giving the Super 8 archive to you?*

JM I met Derek because of the Super 8s, and I think I was one of the few people who took Super 8 film seriously. I got told off by some of the more senior filmmakers at the Co-Op for showing Super 8: they said serious filmmakers make 16mm films. But my contemporaries were all working with

Super 8 and I suppose he thought I was somebody who would take good care of it.

BR *In the 1990s, many young artists started using 16mm once more, even Super 8, attracted by the image quality and its materiality. Did you ever consider copying the Super 8s to film stock to make them accessible in an art context?*

JM Derek's a famous filmmaker now, but although he was critically acclaimed, when he was alive they weren't throwing money at him. The budgets were tiny, and the mechanics of filmmaking are always expensive. As for the materiality of film, it's sometimes fetishized by artists. It would be possible, thanks to the conservation project, to make superior film prints, such as digital intermediates, which are now standard practice in the industry. Projecting Super 8 as Super 8 is a poor option, because the projectors are not very good.

BR *And now that the conservation project is finished, how do you see the archive functioning in the wider world?*

JM Well, I see it as a complete archive of work accessible to viewers, artists, students, curators and writers. It can be shown to the public in different ways. The important thing is that now every single frame is accessible, which I think is unique in an artist's film work.

BR *I imagine there's a lot that has never been seen?*

JM Derek sometimes ran short of film spool, so in order to free up space he would wind one film on top of another. So I found a few films that I had never seen or didn't know existed. He kept all the fragments, he didn't throw anything away. He just assembled them into the dozen reels he called *It Happened by Chance*.

above **The film reel for *Burning the Pyramid* (1973), as noted on the accompanying case.** *overleaf* **Dramatically lit close-ups of Scarlett in *B2 Movie* (1981).**

So there are all the little bits, the failed experiments, the snatches of his domestic life or what's happening on the street outside his window.

BR *This brings us also back to how interpretation and presentation define a work. A crucial element of the archive is that the knowledge of how things came to life is part of that archive too. How have you integrated your personal knowledge and experience into it?*

JM There's another small phase of the archive work that I still have to do. I'm going to interview all the available people who took part in the films and get a verbal record of that time, and of how the films were made.

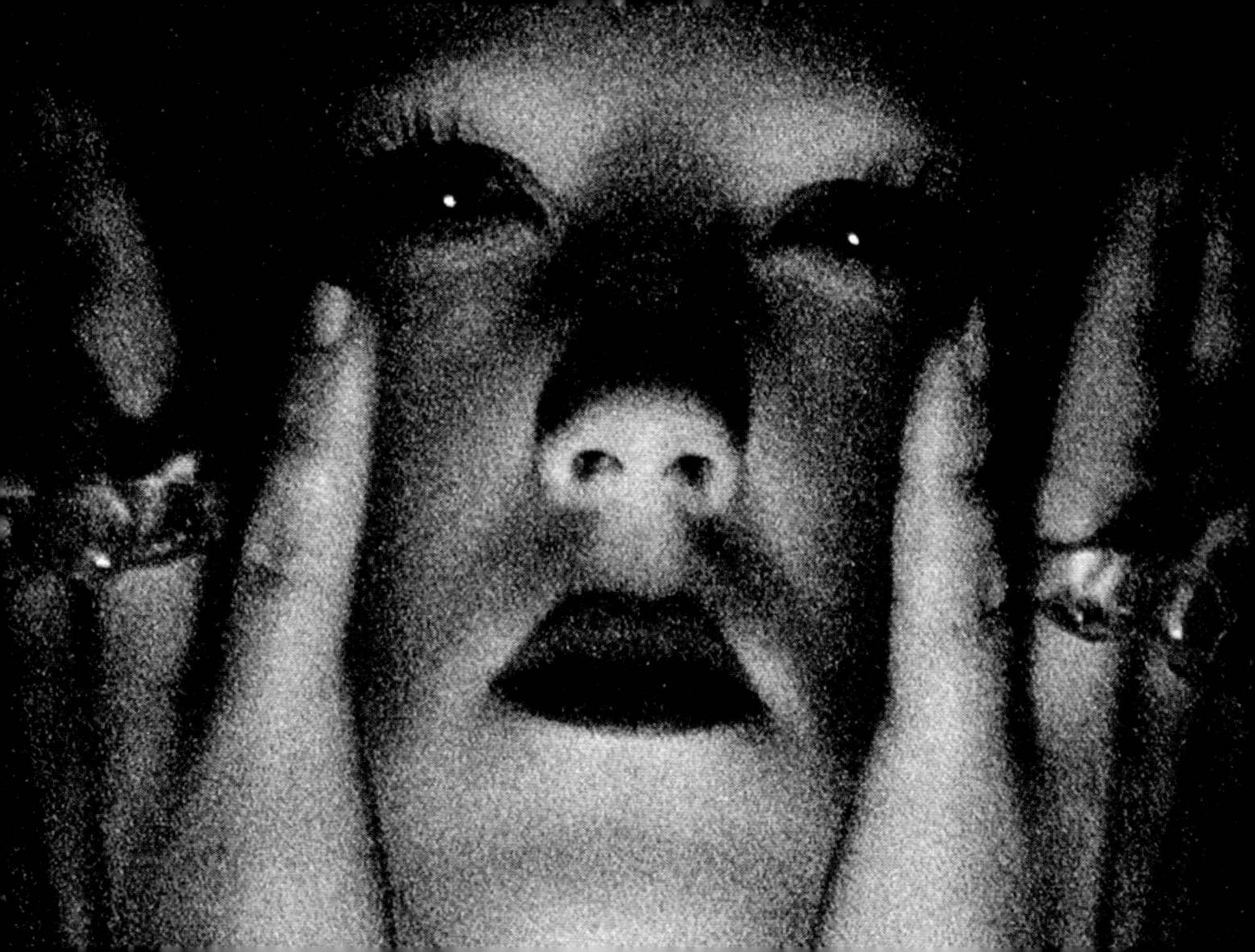

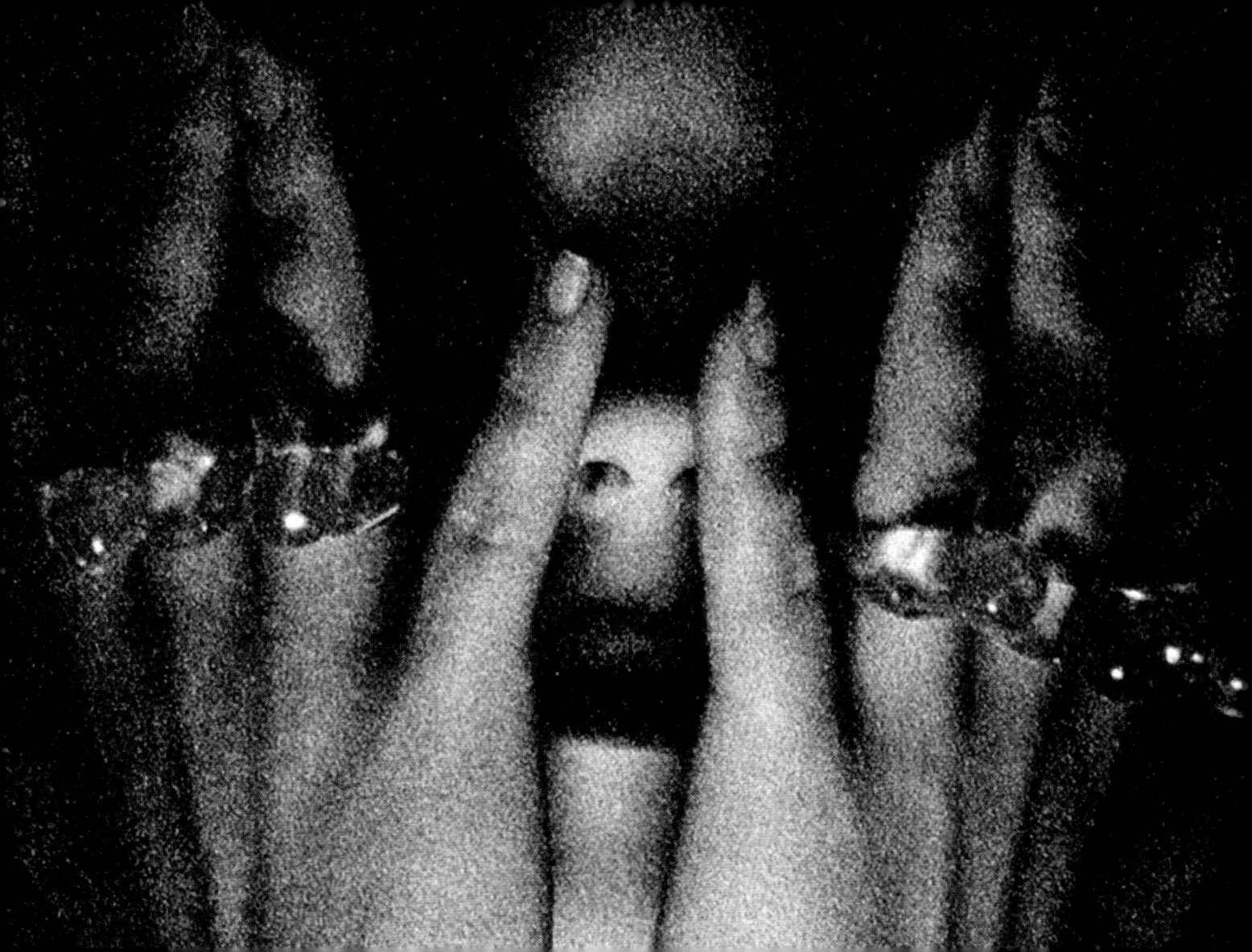

SLNC IS GLDN

JAMES MACKAY

opposite **Super 8 storyboard notes from an untitled sketchbook (1974) in which Jarman entertains the idea of painting or masking frames.**

I saw my first of Derek Jarman's Super 8 films in 1974, when I was still at art school, at a cinema event at the Institute of Contemporary Arts, London. Later, when I was in charge of the cinema at the London Filmmakers' Co-Operative, I contacted Derek and asked him to show a programme of his films. He turned up on the night with a large holdall slung over his shoulder containing a selection of his films, the audiocassettes that he used for the soundtracks and his two Bolex projectors. He showed around fifteen films that evening, each one a gem. He introduced each work as he threaded it into the projector, and continued talking as he put on the music cassette. Rather than playing the films chronologically, he chose the next film to build on the mood of the audience, in much the same way that a DJ selects tracks to play to the crowd.

Though Derek didn't engage with Super 8mm film until the early 1970s, he had been exposed to filmmaking as a child. Both his father and his maternal grandfather were enthusiastic amateur filmmakers, shooting family outings and events in 16mm, his father later using glorious Kodachrome colour. Perhaps it was as a reaction to all things connected to his father that it took Derek so long to pick up a cine camera, but he certainly made up for lost time, creating no fewer than forty-two films between 1972 and 1975. The year 1975 was when he made his first feature film, *Sebastiane*, although by his reckoning the long-form Super 8 *In the Shadow of the Sun* (1972–74) preceded it as a feature work.

It's clear to see why Derek and other artists were drawn to Super 8: with its easy-to-use pre-loaded film cartridge system and point-and-shoot technology, it was a huge leap forward

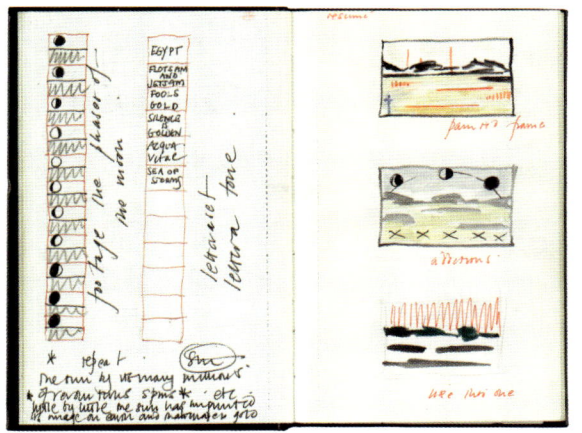
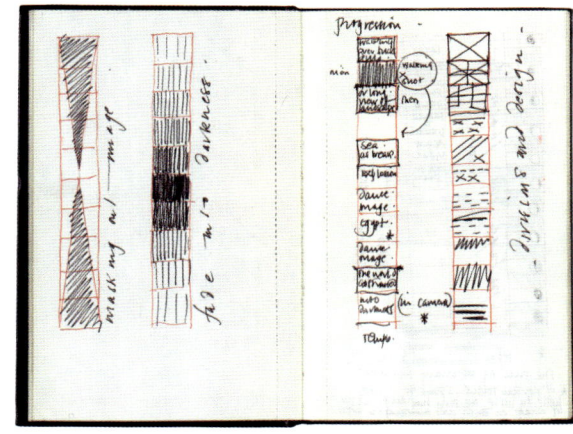

from previous formats that involved heavy and costly camera equipment (16mm) or fiddly loading mechanisms (Standard 8mm). Projectors with automatic threading were also becoming the norm. Shooting with his Super 8 camera left Derek free to interact with his friends and shape the action, without having to worry about position and lighting. This is not to say that his preparation or execution were sloppy; they were anything but. Derek carefully worked out ideas in his notebooks prior to filming and documented them shot by shot.

Derek is often seen in photographs, and in his own films, with his trusty Super 8 camera as hand-prop next to his ruby ear stud and turned-up denim collar. When I first met him, Derek had a beautiful limited-edition Polaroid camera in metal gilt with leather panels. Later, he replaced this camera with a miniature 110 Pentax SLR. He was also drawn to the elegant design of Dieter Rahms's Nizo Super 8 camera in silver and black, its grip folding back onto the body of the camera when not in use. The black leather shoulder holster made carrying it effortless, so it was always to hand. In those days before the internet, a specialist shop in Piccadilly provided Derek with all the accessories, film stock and repair services that he required. The main problems with the Nizo cameras were slippage of the back focus and shedding of the tiny silver metal screws that held it together; a watchmaker's screwdriver was essential kit.

Derek favoured Kodachrome over all other film stocks. Its vibrant colour (it was a dye-additive film stock, producing deep jewel-like colours not a million miles from Technicolor) needed bright light. If conditions were gloomier, Derek would shoot

above **Derek Jarman filmed by Cerith Wyn Evans during** *ICA* **(1982).**

opposite **Jarman's record player and amp at his warehouse studio, from** *Studio Bankside* **(1972).**

and be visible on screen. He quickly moved to cement splices, which are stronger and less obtrusive but much harder to perform. His cement splices, still perfectly solid today, were performed in the blink of an eye while carrying on a conversation, which begs the question why Derek always presented himself as something of a technophobe.

Derek's two compact Bolex Super 8 projectors were capable of projecting at 18, 12, 9, 6 and 3 frames per second. In the later films he made much of this facility, which combined with the slow shooting speeds attainable on the Nizo camera to produce the dream-like stepping effect that became his hallmark. This quality is readily seen in such films as *Picnic at Rae's* (1974) and *Gerald's Film* (1975).

Super 8 is essentially a silent film format, not really designed for sync sound recording, and Derek used it as such, setting recorded music from vinyl or cassette against his films. His choice reflected a wide-ranging taste in music, from Elgar to Lou Reed, Britten to The Kinks (I've indicated some of his music choices in the filmography at the end of this book.) Occasionally a new track would drop into his lap and replace an earlier choice – Varese trumped Tangerine Dream on *Burning of Pyramids* (1973), for example. Derek used music both as simple accompaniment and as commentary. Independent recordings have a different quality from music composed specifically for the purpose. The latter is an interaction between the film and the composer, counterpointing and echoing what is happening on screen. A record, on the other hand, one fitting the rhythm and the

in the faster but less colourful Ektachrome, or in black and white. He would often mix colour and black-and-white footage during filming and in the edit, as in *Fire Island* (1974). The preloaded film cartridge had the dual advantage of ease of use and completely enclosing the film so that there was no short-term danger of fogging; additional cartridges could be carried in the pocket and removed from the wrapper ready for use as needed.

In the early films, on occasion when the film was spliced instead of being edited in camera, Derek used tape slices. These are easy and convenient to use but inclined to stretch

style of the film, gives rise to a whole series of coincidences – moments when the image and film work together or 'click', in a way that can't happen with a score. (Later, Kodak introduced Super 8 film with a magnetic strip, which could record sound. The cassette was a different, slightly larger, design and so needed a different camera, one specifically designed for Super 8 sound recording. Since the film, even at 24fps, travels through the camera fairly slowly, the quality of the recorded sound is poor. The cassettes also had a tendency to scratch the film emulsion. You couldn't record sound if the camera was being used the way that Derek used it.)

Several filmmakers were an influence on Derek at this time. He was a great admirer of Jean Cocteau; when we first met he asked me to see *Le Testament d'Orphée* (1960), Cocteau's final summing up of his art and poetry. He often mentioned Bruce Baillie's *Mass for the Dakota Sioux* (1964) and Jack Smith's *Flaming Creatures* (1963). Kenneth Anger was also a major influence – especially *Puce Moment* (1949) and *Eaux d'Artifice* (1953). So while Derek's Super 8 is startlingly original, it is also part of an international body of avant-garde work.

Derek's Super 8 films were made to be viewed in a different way from conventional cinema, and were shown in formal cinema spaces only rarely. Mostly they were projected to individuals who were free to move about or chat to their neighbours rather than to a still and seated audience. That the films had no dialogue and a fairly abstract narrative enabled a certain ambience. They were also shown in gallery spaces where the audience would mill

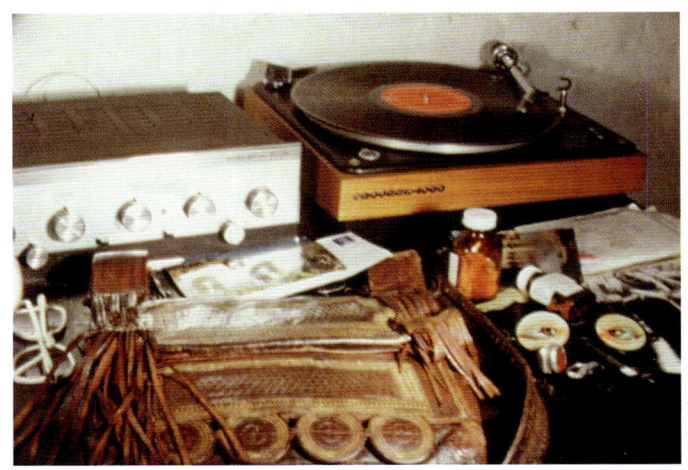

about and come and go, much like many contemporary artists' video works are screened today.

At Low Tide (1972), probably Derek's first Super 8 film, is physically edited from the filmed material. This was shot in Dorset, a favourite Jarman location. The siren, elaborately costumed by Andrew Logan, calls the sailor to the rocky shore. There is a sense of staging that carries over from his first ever film, *Electric Fairy*, but this is quickly lost as Derek begins to respond to his actors rather than direct them – that is, setting up a scene and allowing the actors to improvise, until he found what he wanted in their improvisations. This works well with non-professional actors but less well with professional ones, whose carefully learned methods can get in the way.

Derek's early works, including *Studio Bankside* (1972), are edited entirely in the camera. One useful trait of Super 8 is that the cameras generally stop and start on a single frame, making in-camera cuts possible without any causing flash frames. *Studio Bankside* is a film in two parts. First, we are taken on a journey around the artist's studio at Bankside, on the Thames. Objects are filmed as they appear in photographs, then again as they are placed in the interior of the warehouse. The second part, in black and white, documents the exterior around Bankside and the Thames itself. On more than one occasion, Derek told me that 'Bankside' had been filmed first and 'Studio', the coloured part, second. They are linked by the image of a light bulb with a visible filament, a motif that features frequently in Derek's early film and design work.

Journey to Avebury (1973) is precisely that: a long car journey to the great stone circle in Wiltshire, filmed through a yellow glass filter. When Derek showed the film in the late 1970s, he would skip the long sequence in which suburbia slowly gives way to countryside, and come in straight at the point when we see the first great stone. This version of the film runs for ten minutes and comprises a series of views of the standing stones and their surroundings. It is a beautiful and poignant landscape film: Avebury was close to Derek's heart and closely reflects the abstract style of his paintings and drawings at that time.

Much later, after Derek died, Jhon Balance of Coil called me and said that Derek had appeared to him and told him to write a soundtrack for *Journey to Avebury*, which he did. I think it's a great film, but I knew that Derek, just starting out in filmmaking and still technically inexperienced, hadn't properly compensated exposure for the yellow filter that he had used, resulting in a darker image than he had wished. During the conservation process I was glad to be able to rectify that and render the film in its full, intended glory.

After *Journey to Avebury*, Derek moved to editing films physically, using first a tape splicer and subsequently a cement splicer, the latter providing a less visible and more stable join. These films all have a narrative structure, albeit slight; in *I'm Ready for my Close-Up* (1972), Gaby is dressed in a green frock – the frock is really Derek's focus for the film – as she prepares herself for a male hustler and the night ahead. Andrew Logan provided the scenery. In *Tarot* (1973), Christopher Hobbs, costumed and made up as 'The Magician', consults tarot cards and conjures up a vaguely sadomasochistic scene between himself and Gerald Incandela, all shot in deep red and black. The lush scenes in the Magician's apartment were filmed in Hobbs's Islington bedsit, while the red outdoor sequences took place in the back lot at Butler's Wharf. *Red Movie* (1973) features Incandela in a gabardine coat being pursued through the gardens of Kensington and Kew, before ending up in the greenhouse bed that occupied centre stage at Derek's Bankside loft. It's one of the very few films by Derek that feature explicit queer sex.

From 1972 onwards, Derek – to an extent aided and abetted by John Du Cane – developed a body of films using multiple layer superimposition. Given the domestic nature of Derek's work

environment, these films are very sophisticated, with as many as eight layers of image superimposition, as used in *In the Shadow of the Sun*. The visual effect of this layering is that detail is suddenly obscured or revealed by changes in the density of each layer. Images don't just appear; they arise out of an abstract ground, float on the screen then disappear again. In *In the Shadow of the Sun*, this technique, combined with a very slow projection speed, delivers a hypnotic quality that builds to a series of (actual) explosions at its climax. Both in filming and in superimposition, Derek would often alter colour by introducing filters in front of the lens. *Journey to Avebury* is filmed through a yellow filter, *Red Movie* through a red one, and a glass prism held in front of the projector lends a rainbow of colour to the black-and-white footage of *My Very Beautiful Movie* (1974).

A number of Derek's Super 8 films were elaborately masked and costumed by Christopher Hobbs and Andrew Logan, and are peopled with extravagantly dressed actors: in addition to Hobbs and Logan, Luciana Martinez, Kevin Whitney and Gerald Incandela appear frequently. As there is never any audible dialogue, Derek was able to recruit actors from among his friends rather than use professionals. This became his preferred way of working, and when his more conventional feature films demanded little dialogue he would often choose non-actors, preferring to cast for look and type. In all his Super 8 films he worked with a fairly small, tight-knit group.

Living at Butler's Wharf gave Derek access a large piece of waste ground right on the Thames, which he claimed as

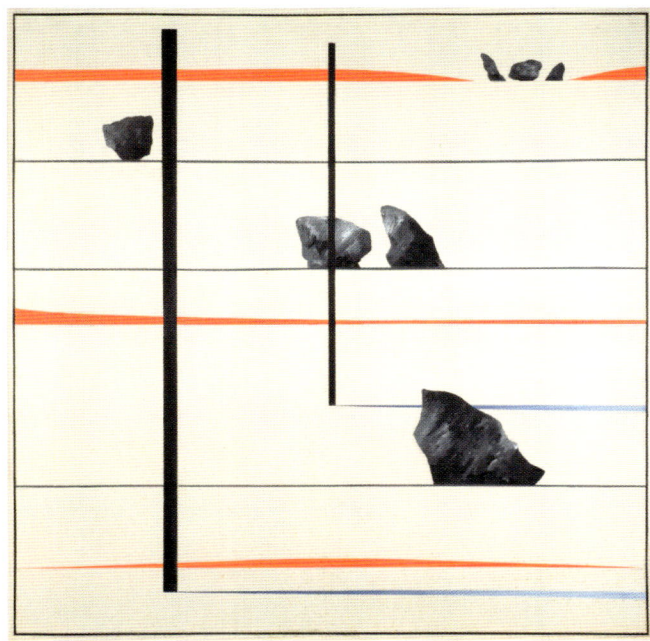

Derek Jarman, *Avebury Series No.4***, 1973.
oil on canvas, 120 × 120 cm / 47¼ × 47¼ in.
Northampton Museums & Art Gallery.**

his studio on warm and sunny days. Here he began work on *The Art of Mirrors* (1973) series of films, which featured fire mazes, alchemical references and masks. These magical elements were conjured up with prosaic materials: paraffin-soaked sawdust provided the fire mazes, banks of candles gave illumination, and decorated paper bags became masks for his actors to wear.

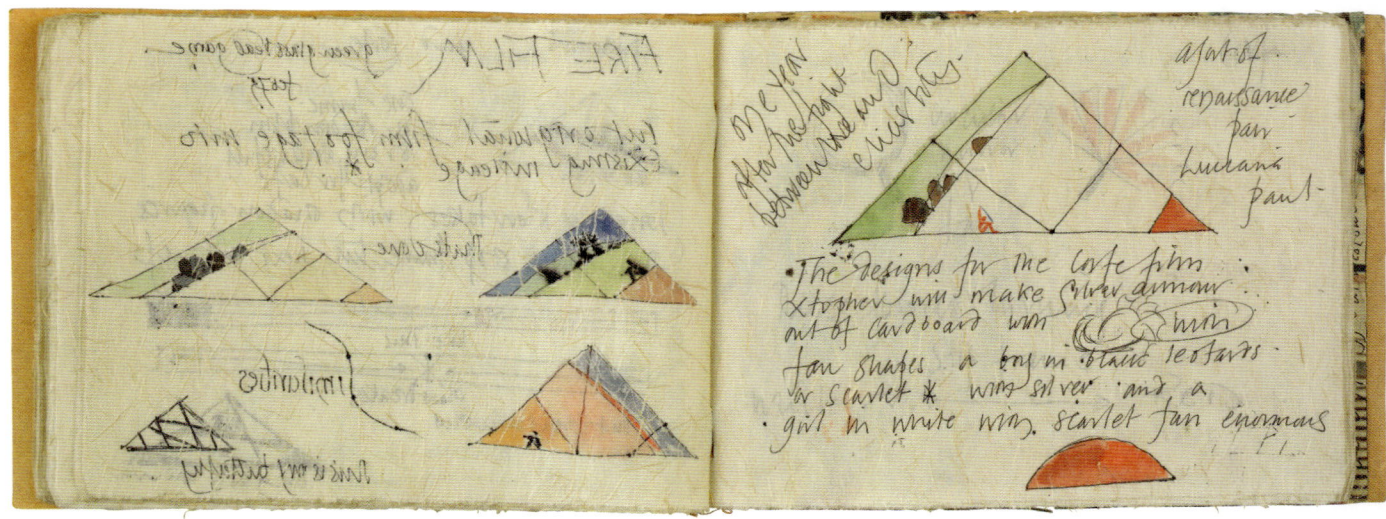

Jarman's designs for *Corfe Film* (1975) from an untitled handmade sketchbook.

Mirrors played into the camera lens are a constant motif, held by the actors as they transit across the screen in dream motion.

In his autobiography, *Dancing Ledge* (1984), Derek writes:

During the summer of 1973 I filmed the main sequences of a full-length Super 8 film — In the Shadow of the Sun, *which was to wait eight years before it saw the light in 1980* [actual date, 1981] *at the Berlin Film Festival. The first sections were already filmed a year before, in 1972* — A Journey to Avebury *and* The Magician — *and the final sections were filmed in 1974 on Fire Island before the whole thing was put together. The camera I used was a simple Nizo 480 which cost £140. Most of the sections were filmed for the price of the stock, usually about £20 — some lavish sequences, the fiery mazes for instance, had a budget: costumes £5, sawdust £4, paraffin £2, roses £10, candles £4.50, notebook £1, taxis £5. The film was structured around a series of cryptic phrases which appear briefly in the film as Penny types them with one finger — these are some of them:*

SLNC
IS
GLDN

Little by little the sun had imprinted its image on earth and that image is GOLD. – *Then other titles,* The Kingdom of Outre Mer *and* Ronde de la Mort. *The work changes from day to day like a kaleidoscope. I wrote in the diary* – *'I've failed to develop in the way that was expected.' 'Am I certain the picture I'm looking at accurately portrays the contents?' The film-makers I showed the films to were generally uncomprehending. No one took Super 8 particularly seriously* – *they all had technical training, could read numbers on light meters, and so worked in 16mm. I was fazed by numbers and am hopeless with machines. I have never learned to drive a car. The film-makers at the Co-Op were involved in the destructuring of film; to one who had stumbled on film like a panacea this seemed a rather negative pursuit* – *like calling water H2O. When I received my first film back and it was in focus, the whole thing seemed magical* – *an instrument to bring dreams to life, and that was good enough. I disliked the subsidized 'avant-garde' cinema. There was a strong official line; but Super 8, which cost next to nothing, allowed one to ignore that. The resources were small enough; so if independence were a form of purity, I had my hands on the philosopher's stone. In 1974 I bought Jung's* Alchemical Studies *and* Seven Sermons to the Dead, *and this provided the key to the imagery that I had created quite unconsciously in the preceding months; and also gave me the confidence to allow my dream-images to drift and collide at random. . . .*

This is the way the Super 8s are structured from writing: the buried word-signs emphasize the fact that they convey a language. There is the image and the word, and the image of the word. The 'poetry of fire' relies on a treatment of word and object as equivalent: both are signs; both are luminous and opaque. The pleasure of Super 8s is the pleasure of seeing language put through the magic lantern.

The images of In the Shadow of the Sun *are fused with scarlets, oranges and pinks. The degradation caused by the refilming of multiple images gives them a shimmering mystery/energy, like Monet's* Nympheas, *or haystacks in the sunset. There is no narrative in the film. The first viewers wracked their brains for a meaning instead of relaxing into the ambient tapestry of random images. The language is there and it is conveyed* – *and you don't know what you have to say until you've said it. You can dream of lands far distant.*

The film became divided in my mind into four sections, although it was not constructed in that way. The first section is based on a journey to the standing stones at Avebury in Wiltshire, coupled with two fire mazes. It contains a man who points, another who takes photos, a third in bondage, and animals – *dogs and a sacred cow. There are burning roses which occur throughout the film. The second maze is circular* – *Ronde de la Mort* – *in which a couple dances in the flames which devour the whole landscape and the great standing stones. A third and final image of Narcissus, a mirror which flashes the sun into the camera so that the image explodes and reinvents itself in a most mysterious way. This section is brought to a close with some refilmed footage off the screen at the Elgin Cinema in NYC from* The Devils – *the final moment when Madeleine escapes from the claustrophobic city of London into the world outside, over the great white walls; but now, in my version, she walks into a blizzard of ashes.*

The second section is an invocation. Black and white masked figures walk through the flames. A magician finds the key to a cabinet

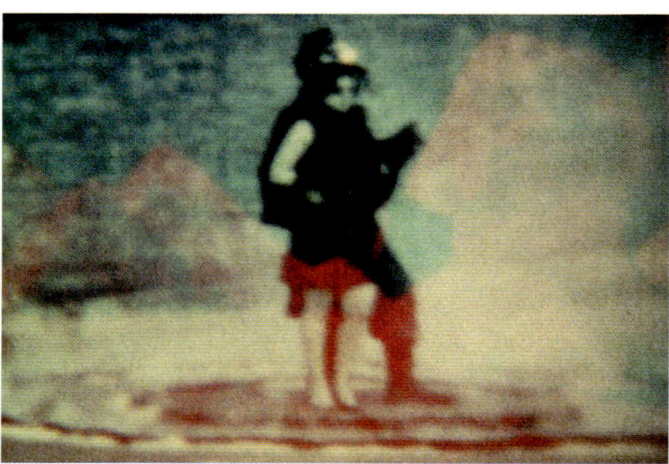

**Andrew Logan and Luciana Martinez
dance in the fire maze, multi-layered visuals
from *In The Shadow of the Sun* (1972–74).**

of secrets. Now we are in the kingdom of the other sea, where an Egyptian pharaoh materializes in the surf, ushered in by a bacchante who dances in black with the herb of grace. Atlas supports the worlds lost in the galaxies. Dancing at the edge of time. The section ends with a figure turning in a magic circle, which burns the film out to white.

The third section contains the typewritten messages. The images are evanescent. The pyramids burn to a candlelit requiem, the people gamble and barbarians ride through the ruins.

In the final section the images fade into blank footage where the atoms dance, punctuated by explosions, and a figure listens to a message on a shell:

SLNC
IS
GLDN

Garden of Luxor (1973) utilizes footage from an early 'swords-and-sandals' epic in its superimpositions, and presents a vision of an Arabian garden rendered through vintage postcards of Alexandria (also reproduced in Derek's book of poems, *A Finger in the Fishes Mouth*). These images are intercut with a posed tableau of a young man dressed in vaguely Arab garb lying on a bed of pillows, a giant egg (or, rather, a hen's egg made to look giant by placing it near to the camera), and Christopher Hobbs – his nose painted black in emulation of a skull's nasal cavity (an effect also employed for Max in Derek's feature film *Sebastiane*) – alternately cracking a whip and eating flies. Egypt materializes: maybe the memory of passing through the Suez Canal as a child had inspired Derek. He was always fascinated by the country, although his project on the maverick pharaoh Akhenaten was never realized.

The island of Møn off the coast of south-eastern Denmark is renowned for its natural beauty. *Ashden's Walk on Møn* (1973) is in two parts. First, in black and white, we trek through a forest and down some steep wooden steps leading to the bottom of a cliff face. A photo of a star nebula is superimposed over the whole. The second part, in colour, is of a series of still views of a green landscape peppered with small mounds, much in the style of *Journey to Avebury*. These sequences are

intercut with very short bursts of similar images shot through a red filter. It is one of Derek's most enigmatic and abstract landscape films.

Derek's beloved Dorset appears in so many of his films – *At Low Tide* (1972), *Jubilee* (1978), *Corfe Film* (1975) and *The Angelic Conversation* (1987). In *Corfe Film*, a knightly pageant is shot amid the ruins of Corfe Castle. Luciana Martinez waits on the battlements in a resplendent gown, her hair crowned with stuffed birds, as a knight in shining armour (the casque made out of silvered paper by Hobbs) approaches but never quite manages to arrive. *Corfe Film* is an unfinished work, or perhaps it can be understood as a 'structuralist' one, reflecting the flavour of avant-garde film of the time.

In *At Home with Duggie Fields* (1974), the eponymous painter is portrayed in his apartment, where the distance between objects and paintings is very small, and art and artist almost merge into one. Like all of Derek's portraits of his friends and contemporaries, this reflects the nature of his subject in a gentle and loving way, although, in this instance, the film features a young man whom Derek brought with him.

The apartment in *Sloane Square* (1974–76) belonged to Anthony Harwood, and was home to Derek and Guy Ford in the mid-1970s until Harwood's sudden death in New York and their subsequent eviction. It was decorated with full-wall grey glass mirrors, which give the impression of huge depth. Using these, Derek records daily life in stop-frame motion. Black-and-white serenity eventually gives way to colour for the eviction party, or 'Removal Party', as Derek called it. In the early 1980s this was the first Super 8 film that had a soundtrack specially composed for it, and it was also Simon Fisher Turner's first soundtrack. Simon, a friend of Derek's who had worked on *The Tempest* (1979) with him, was also a musician, so Derek suggested that he write music for the short film that we had just transferred to 16mm and wanted to show in public. For Simon, it was the start of a long musical collaboration with Derek, and an illustrious career as a film composer. It was at this Sloane Square apartment that *Sebastiane* (1976), Derek's first cinema feature, was hatched. He filmed Ken Hicks there (*Ken Hicks*; 1975), in a slow, sensuous single take, as a screen test for the part of Adrian. Filmed against the grey glass mirrors that clad the walls, Hicks performs a sensuous strip before rubbing oil into his skin and scraping it off with an antique strigil, in the way that a Roman legionary would have done.

The end of the *Sebastiane* shoot in Sardinia was commemorated with *Sebastian Wrap* (1975). (Derek hated the 'e' added to the title at the behest of the film's distributor, always referring to his film as just *Sebastian*.) It is not, as has been written, a film of a wrap party, but a long, static image of a group of actors as they lie face down on the pebbles of Cala Domestica sunning themselves, while Guy Ford stands between them and the camera, holding a large sheet of Mylar, a partially reflecting material and the 'wrap' of the title, which causes them to appear and disappear from view. It is one of Derek's most beautifully lyrical films.

After *Sebastian Wrap*, Derek abandoned the tripod and the static shot that had been an almost constant feature of his films in favour of a hand-held camera. Beginning with *Ken Hicks*, he filmed at a slow frame rate, following and almost caressing his subjects, and moving with and around his sitters. The two outstanding examples from this period are *Gerald's Film* (1975) and *Art & the Pose* (1977). These portraits, which both feature Gerald Incandela, are filmed in continuous takes and interrupted only by the need to reposition for in-camera edits. In an application to the Arts Council for funding, Derek refers to maintaining the integrity of the Super 8 film cassette, capturing a place or person in a single fluid take, enhanced by filming in a kind of stop motion (under cranking) and then projecting the resulting film at a similar, but not identical, speed. This imbued his films with a dreamy, floating quality and resulted in some of his best work. *Gerald's Film* was made during a walk through the Essex countryside, where they came across a decaying Victorian boathouse. Derek filmed Gerald, wearing a hat from a Pasolini film, in pastel tones among the ruins. *Art & the Pose*, filmed in black and white in Gerald's loft apartment, also features the photographer Jean-Marc Prouveur. One of the central images, a re-enactment of George slaying the Dragon, was later used by Derek as the basis of a series of paintings. The film ends with Derek's camera sweeping past a heavy curtain, where George and Jean-Marc are playing hide and seek, to the view of the Empire State Building through the window, which locates the film geographically.

Following *Sebastiane*, Derek accepted working in 16mm more readily. Peter Middleton (the cameraman on *Sebastiane*) had shown him that he could work in a more conventional format without losing either control or the informal atmosphere that he valued so highly. *Jubilee* (1978) incorporated Super 8 at its heart, in the sequence of Jordan dancing around a bonfire, which Derek also edited as the standalone Super 8 film *Jordan's Dance* (1977). Jordan was one of the pioneers of the punk movement, turning heads as she walked down the street wearing rubber and extraordinary make-up. Derek first saw her in Victoria Station, where they had both gone to catch a train. She wanted to be a ballerina; he wanted to film her dance.

The beginning of the 1980s found Derek involved with an independent gallery run by David Dawson at B2 Metropolitan Wharf, a warehouse facing Butler's Wharf across the Thames. Derek contributed enthusiastically to the film and painting exhibitions there. In addition to showing existing film work, he titled a new work, a film diary of the preceding year, *B2 Movie* (1981), and premiered it in the gallery. Another work, *Pirate Tape* (1982), came about through an event organized by David Dawson and others, The Final Academy, which featured work and readings by William S. Burroughs, Brion Gysin and John Giorno. The gallery staged a show featuring Ian Somerville and Brion

opposite **Derek Jarman, *Untitled*, 1981, oil on black & white photograph of a frame from *Art & The Pose* (1977). 34 × 27 cm / 13 ⅜ × 10 ⅝ in. (including frame). A Christmas gift from Jarman to the author.**

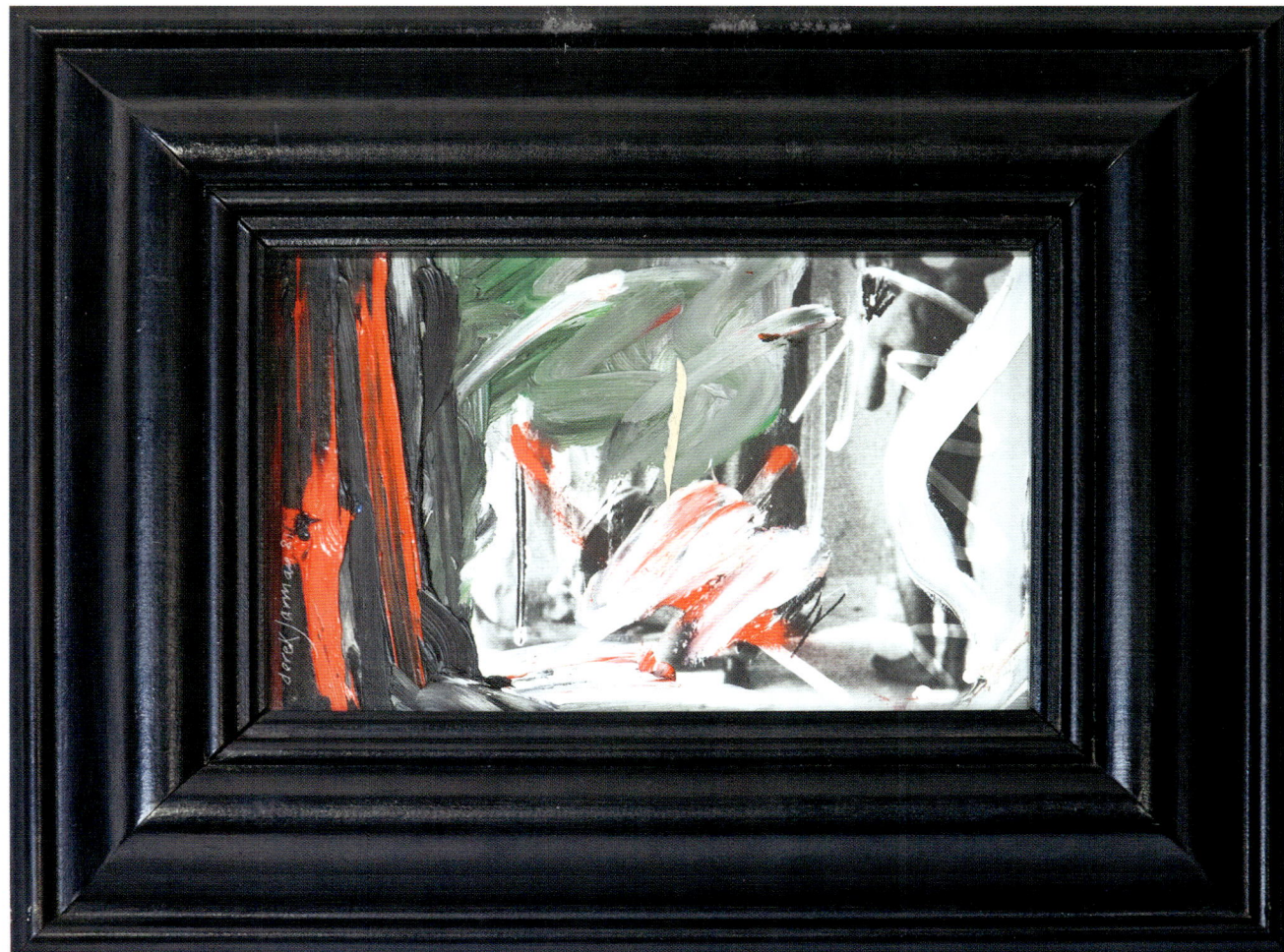

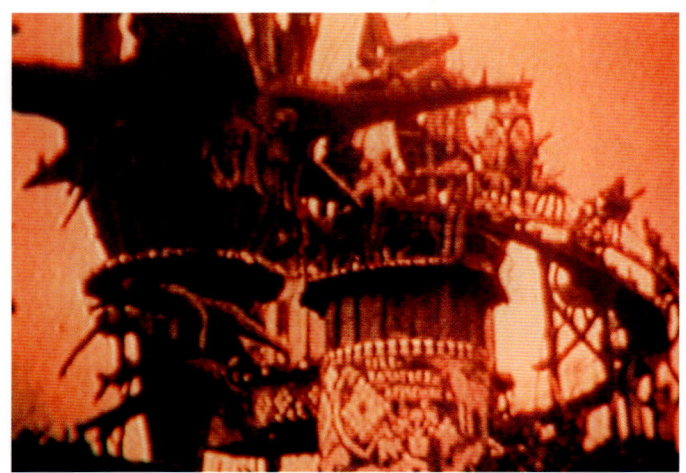

A still of a sculpture park outside Baku, Azerbaijan. *Imagining October* **(1984).**

Gysin's *Dream Machine* hypnotic sculpture, and the storyboard for a film of *The Soft Machine* by William Burroughs and Antony Balch. Derek filmed 'Uncle Bill' Burroughs in his by now signature single-take, swooping portrait style on the pavement of Tottenham Court Road as he arrived to take part in the underground feature film *Decoder*.

The following year, Derek filmed rehearsals for a performance of *Waiting for Godot* at RADA from the TV screens that constituted part of the set design. In the resulting film, *Waiting for Waiting for Godot* (1982), the cast and crew are rendered as ghostly, fleeting images as they mill around the stage. Although one of Derek's more abstract films, recalling *Sulphur* (1973) and *Stolen Apples for Karen Blixen* (1973), it is also recognizably a document of Beckett's play.

Over the years Derek also made twelve volumes of cut-up and diary films entitled *It Happened by Chance* (1972–83), compiled from snippets, out-takes, films that didn't quite work, and other odds and ends. Some of it is fascinating: snatches of rehearsals for *Silver Apples of the Moon*, a ballet for the Coliseum, which Derek considered to be his finest stage design but was only performed once, in Oxford; domestic scenes with lovers, friends and family; a Sex Pistols performance at one of Andrew Logan's parties (the black-and-white sequence having been incorporated into Julien Temple's *The Great Rock 'n' Roll Swindle*); fragments from a journey across the Soviet Union. Derek would usually play these as single or multi-screen projections and at very slow speeds – like an ambient installation of ever changing juxtapositions. Simon Fisher Turner later created drifts of dream music to accompany them.

With the arrival of VHS video in the early 1980s, filmmaking became even more accessible and acquired an interestingly different look. Derek quickly picked up on this; he was never a format snob, trying his hand at any new format that came his way, interested to see what it could do. If he liked it, he would assimilate it into his filming palette. Influenced by other, younger, artists, he began to mix Super 8 and VHS, copying Super 8 footage onto video by projecting it onto a white card and refilming it with a domestic video camera. He played with

ADOLESCENCE
Stolen at the Point of Obsolescence

LIAM GILLICK

opposite **B2 Movie** (1981).

To hold a camera like a torch that craves light. To not leave the house or studio or rooftop. To stand still in the warehouse when alone and direct your gaze towards a highlight. These are things to do. To make film alone is a form of freedom. To be the camera operator and director, without others to interfere or take control. The camera and projector are related to each other, and Derek Jarman would turn his camera away from the burn for a moment to film projected footage. Filtered light and pure flame. Projection and reception. Capturing light and throwing shadows.

This is what Derek Jarman found with his Super 8 camera. A flash, a burn, a lingering subject. A subject directing light back towards the lens — sending a message, nearly flashing morse. A camera fixed on its lax subject returns the gaze without emotion or recoil. A director who has escaped the burden of 'directing' for a short few minutes once again has the opportunity to turn towards a point of focus just at the same moment that the subject seems to send it right back towards the camera. There is no watcher and watched here, but rather an exchange of fire and light.

To have a camera to hand — just by your side. To hold the camera with ease and balance. To film yourself in reflection. To lean towards the light from a shadow. This is real. The ideal is to have the camera loose by your side and bring it up to the eye at will — no transition between discussion and a moment of record. The best thing is that you can leave it alone and nothing happens — there is a clear sound when the camera films and when it has stopped. The subject knows when the camera is running. The subject can hear time moving, pushed by sprockets.

A Super 8 camera often has unfinished film in it when it is not being used. The roll of film is something to save carefully or get through rapidly, with abandon. Capturing and letting go, simultaneously. The great period in which to use the Super 8 camera was the transitional moment between film and video. The camera seemed so slight, so light, in comparison to the semi-functional bricks with low-res capacity that were already just sitting there smirking, expensive and incapable of filming Derek Jarman's points of light without ghosting, burning out and losing all precision. This is the light mockery within Jarman's Super 8 films. The constant turn towards those spots and point and luring glows — all in resistance to the barked warning when you first picked up the video Portapak. Do not point it towards a direct light source, you were warned. Stay away from the bright lights. Beware of spots, and don't burn out the CCD. And don't burn out.

The late Super 8 camera — from the early 1970s onwards — tended to come in the form of a rectangular block, vertical on its long, thin edge, with a lens at one end and a viewfinder at the other. With the introduction of motorized film movement and powered zoom, the solution for storing the batteries was to incorporate them into a forward-mounted pistol grip that you could then grasp to hold the camera. The batteries gave the handle a weight that produced an easy balance in relation to the lightweight body of the camera and made the whole device easy to hold steady. The form and the function of late Super 8 cameras are precisely aligned. With the advent of HD filming using cameras with a traditional SLR body it has become necessary to add various grips and struts in order to get anything like the same degree of utility. It is the pistol-grip form that has become obsolete, yet it lends the artist a particular stance when seeking the reflection or the light. The artist points the camera at the mirror, and we just see their fist and the lens. The camera can be directed; it does not require someone in between to take instructions. It reveals a lot of face. You can see the operator quite clearly behind this narrow form. When you pick up the Super 8 camera, there is little doubt which way to direct it.

In 1986, my Canon 514 XLS Super 8 sound camera was stolen from 14 Netley House on Southampton Way Estate in Peckham, south London. This was not the best Super 8 camera, but it was bought at the moment of its obsolescence. Not at the base of its price, or yet as a relic sitting among house-cleared junk, but just as its value was tumbling — while it still had some sense of use and value, while the seller still believed they had something worth giving up. By contrast, my Nikon 8x Superzoom was given to me free with a $1 book purchase at a yard sale a couple of years ago; a better camera, now just confusing and mysterious. With these late cameras there is already something of the aesthetic of the advanced video camera about them. But the discovery of an empty interior, along with the requirement to find film, now renders these beautiful objects as baffling to some.

My Canon 514 XLS was not bought to make films with — although one or two exist. But having a Super 8 camera to hand indicated an intention to do something at some point.

The increasing inconvenience — even at that time — of buying and processing the film made the camera an object rather than a tool. And while it is true that Super 8 film is considered part of a subversive history, the fact that the stock was made by a global corporation, and priced along the same lines as printer ink in 2014, meant that, for an art student, the use of the camera as a thing for making films would be severely limited. Instead, the camera was something to hold. It was a thing used to frame a scene and to allow you to see things within a given mechanical context. The camera was a looking device and represented potential. It was a reminder of something useful for seeking out light. It craved light. It was nothing much without it.

I wanted the camera back. I needed it for the near future. Running into one of the skagheads whose burglary skills were stunted by their tendency to nod out to the heroin in their systems, I asked if anyone knew of a video camera for sale. His eyelids lifted for a second. Yes. He could help me. Wait. He returned, leaning forwards into his hobbled, quick-stepping stride — falling towards me and holding tight to a Londis bag. Here mate. Alright? Video camera. Expensive. Canon. Thanks, I said. It's not a video camera. It's Super 8. A crushed look of incomprehension. What's that? It's a fucking video camera. It's Super 8. It's a fucking video camera … Mate … It's mine. It's a video camera. It's my Super 8. Look. I'll show you.

Pulling the camera from the bag, I dropped the batteries out of the handle in a disarming gesture. I then flipped the latch on the film cassette door and handed the camera over, suggesting he share in its lightness and hollow form. But he didn't want to. The ease of handling and flipping and flicking had convinced him it was mine. He had lost interest. The exchange of the camera had no sense without desire. Ownership crushed the potential of a lucrative deal. He quickly moved out of the light.

Liam Gillick *is a British conceptual artist. He is often associated with the artists included in the 1996 exhibition 'Traffic', which first introduced the term 'relational art'. He played 'H' in Joanna Hogg's film* Exhibition *(2014).*

AT LOW TIDE
1972

Derek dips his toe into the sea of Super 8 filmmaking with the help of Andrew Logan and Christopher Hobbs. It was filmed on the Dorset coast.

44

45

46

DIARY FILMS
'Music Videos' for Beginners

WILHELM SASNAL

opposite & overleaf **Studio Bankside (1972).**

Twenty years ago I acquired a small 8mm camera from my friend's dad. I remember he used to film our friends with it. It was a Soviet model with three lenses, and the handle was detachable; it was so small I could actually put it in my pocket. At that time, in the early 1990s, I could still buy film stock for it, and that was how I started to make films.

Standard 8 was double-sided, so that when I finished filming the reel, I flipped it over and filmed again, then I split it down the middle with a little cutter device.

I didn't start filmmaking much later than I got into painting – I mostly did both. I was always keen on music, and wanted to be a music-video filmmaker. Video was still very expensive, but the length of a Super 8 film was quite like the length of a song – about three minutes – and that's why I liked it.

I first picked up the camera because I was into Polish animation, the short films wave, especially in the early 1990s when I was seventeen or eighteen and public television was quite rich. The shorts were handmade directly on the celluloid, frame by frame. One filmmaker in particular was important to me: Julian Józef Antoniszczak. In the 1960s and 1970s he made non-camera chronicles and became a hero of mine.

As with everybody who starts making films, my first attempts tended to be diaries that recorded my private life, and this is why I feel so close to Jarman's films and find them so interesting. Apparently he used an intervelometer, which allows you to film at different speeds, including very slow ones, so you can do time-lapse. I remember going to Frankfurt with friends when I had only one roll of film, and capturing the entire trip from Krakow

to Frankfurt on 15 metres of film. For me, there were economic reasons, but I think of these diary films of mine and Jarman's as silent video clips. Sometimes I used colourful transparent markers on the films, because all my film stock was black and white, and mostly expired. I couldn't really predict a decent contrast, so I had to really push while developing the film to achieve as much contrast as possible. I learned from scratch how to develop my own film, but the reversal was very difficult, because I had to make something like five baths, if I remember correctly. I had a black box in which to load the film and process it.

I remember seeing Jarman's *Studio Bankside* when Gregor Muir showed it at Tate Modern in 2005, and Coil created a new soundtrack specifically for the installation. Because diary filming is regarded as cheap and unimportant, it tends not to be shown as a proper art. This film is different from the other Super 8s because it is so open – it has a strength, a freshness because it's real and not over-created as with some of his short films. Sometimes I prefer looking at the sketchbooks of artists rather than their big pieces, and so it was with *Studio Bankside*. Of Jarman's work, I knew only *Caravaggio* – a big piece with many holes in it, many open fields and certain conscious inconsistencies that I really liked – but *Studio Bankside* has more life in it. I had thought that some of Derek's Super 8s were filmed on 16mm because they were apparently bigger enterprises with actors, costumes and sets; of course, Super 8 is a cheap cinematographic material.

In my own practice, I look more towards documenting events and spaces rather than drama. Since Kodachrome stopped production I use 16mm, but I miss Super 8. It was easy to collect footage: you could put the camera in your backpack or even in your pocket, film whatever was interesting for you – on the streets, travelling, talking, meeting people, whatever – and combine the snippets into short films. It is very like sketching. I try to create something special using the 16mm camera I have now, but you know in advance what you're going to do, it's a bit pretentious, not as fresh and not as real – it's always inclined to be 'a piece of art'.

Now that I don't use Super 8, I use my mobile to take snapshots as source material for paintings, but I don't mix filming and painting. In both practices I rely on my intuition rather than my knowledge. Recently I've returned to filming my friends and family. I made a sort of short fiction on 16mm with my dad, my daughter and my son, but I filmed them first and then made up the story.

So many of Jarman's stills – his still lifes, images from houses and interior rooms – are like Wolfgang Tillmans's pieces. For me, Jarman's work is very rich, very consistent with his life and times. I watch his Super 8s as video clips without music, and they are really beautiful.

Wilhelm Sasnal *is a Polish painter, comic-strip illustrator and filmmaker. He is interested in passing the tropes of 'high culture' through the filters of mass media, in collective consciousness, and in the space between the public and the personal.*

STUDIO BANKSIDE
1972

The inside — in colour — and outside — in black and white — of Derek's studio at Bankside on the Thames is lovingly captured.

5

7

LETTERS

DEREK
Jarman

013

ANDREW LOGAN KISSES THE GLITTERATI
1973

Derek films Andrew Logan's kisses in this series of tableaux featuring the London beau monde — or, as Derek preferred to call them, the glitterati.

**STOLEN APPLES
FOR KAREN BLIXEN**
1973

Superimposed black-and-white images of Gerald Incandela holding apples pay tribute to Karen Blixen, one of Anthony Harwood's favourite writers.

TAROT
1973

A collaborative fantasy created by Derek and Christopher Hobbs, in which a cloaked magician deals the cards and enters a black-and-red world of forbidden pleasures.

HAPPY ACCIDENTS
Sketchbook Filming

SARAH TURNER

#3

opposite **B2 Movie (1981).**

I came across Derek's Super 8 films at St Martins School of Art in 1987. Their degree in Fine Art, Film and Video was very innovative: the only degree in the country that taught film as a fine art discipline and encouraged experimentation and an otherness – both a cultural and a formal otherness. Many gay women taught the degree. The work of recent graduates – some of it heavily influenced by Derek's filmmaking, such as Isaac Julien's *Territories*, which used re-projected Super 8 – was shown alongside Derek's Super 8s and other radical British independent films. On one extreme there was Laura Mulvey and Peter Wollen's avant-garde work, and on the other was Derek Jarman. The first film of Derek's I saw was probably *T.G.: Psychic Rally in Heaven*, a late Super 8 of his, blown up to 16mm. It is a very late work so it uses several techniques: a moving pen-like camera, stop-frame motion, superimposition and colour alteration.

In that period we were using a lot of Super 8. We had a two- and three-machine Umatic editing suite, but video didn't work for me at all then. I was still stuck on film; I liked its materiality, its tactile nature. I'd never shot a roll of film in my life before I went to St Martins, but I'd taken photographs and done a lot of writing, and what eventually emerges between the two is of course film. I was working on 16mm, and we were taught its full properties, including emulsion, light meters, stocks, ASAs and so on, whereas Super 8 is primarily a domestic format with automatic exposure. Super 8 was largely regarded as a 'sketchbook' medium and that made it popular when I was at the Slade. It's hard to determine in retrospect whether this stemmed from Derek's influence, but the films I made at the Slade used Super 8 to generate imagery that was then refilmed onto 16mm. I undertook

the refilming myself, projecting off the wall in the studios using variable-speed projectors and theatrical filters, with lighting gels to affect the colour. I know that is something Derek did, but I don't know if I'd have seen those films; what I liked was the crushed colour in Super 8 and I was pushing that further through the use of gels.

Super 8 has very different qualities from 16mm, which is more about the 'real'; it standardizes how you see, because you're pushed to use proper exposures and frames. Even in the 1980s 16mm was expensive; if you were a student, you really had to think it through, whereas a carton of Super 8 cost about £5. I would do things like rig a camera in a tree and whip the tree branch around, which I wouldn't risk with a 16mm camera; the Super 8 camera could be used as an extension of the body. It was a much more embodied and light-sensitive medium, so, for example, on a bright day with high sun and lovely, intense shadows, you knew you could create a kind of pattern — flickering, overexposed highlights and crushed, dense shadows.

There is also the alchemy of mistakes. I know from his writing on Super 8 that Derek's lust was also about not having control, particularly on account of the built-in automatic meters in these cameras. A lot of Super 8 stock in my house has been in and out of fridges, so the emulsion will have gone like mud — an accidental deterioration that will give unpredictable results. Derek always incorporated those kind of accidents. There's a tension between being in control — for example, shooting three frames a second — and being out of control that plays throughout his work, through a kind of sadism in *Sebastiane*, *Jubilee*, *Edward II*. The oppositional forces of love and death create tensions that were somehow embodied in the extremities of this medium.

It's complicated to talk about Derek's influence on my own style because I don't have any kind of neat line around it. I think there is the politics of passion, an extreme romanticism that is under siege, so there are these incredible tensions — I'd say those tensions are absolutely played out in my own work. This kind of battle creates a compulsion and a distance that can be played out in Super 8. In my earlier work I was still searching for the way that film stages these battles. The battles are unique to film, because of its 'happy accidents'. No matter how much expertise and craft you have, there will always be something out of your control. For example, Derek played with this with the use of mirrors, bouncing light around, which I've also done. It's the idea of reflecting back, except that you really can't control the effect when you throw light back into a lens; there's burnout and the emulsion is flooded in response. You have no control over its extent, but you struggle to create these happy accidents on film. There's a tension between really controlling what you're doing and having no control at all: it's a fertile and compelling space for an artist to work in.

I met Derek a couple of times in gay clubs and in St Petersburg in the early 90s, when we talked about the horrendous conditions for lesbians and gay men. Derek had a brilliantly infectious radicalism: 'What can we do? Let's do

it now, forget the screening!' He travelled to Russia in 1984 and filmed some quite interesting things, again on Super 8, which became the film *Imagining October*. I was there in 1987–88 and, if you were a Westerner, you were constantly followed by the KGB. I heard many stories of Super 8 cassettes being taken away from filmmakers, so the idea that you could infiltrate was limited. I was shooting on Hi8 stock and felt much more comfortable with that because it looked like audio cassettes. We packaged up the tapes I shot and put them with the stuff that we were listening to on Walkmans. We were paranoid about getting our film taken away because filming was banned.

Derek's work stood out for me as a gay woman because he very explicitly brought this playful, lusty landscape of Super 8 into the realm of the personal. I keep using this word 'playful': I think it's actually a really good word because the exploration of sexuality and sexual politics was playfully radical, and there was a synergy between the playfulness of the medium and the playfulness of the intimacies being represented. Super 8 is more exploratory and light, both in terms of the properties of the emulsion but also how you approach it. It seems to me to be lusty to approach a lover or a tree or a piece of earth in this playful way. He's using the old Nizos, and you can go down to three frames a second, and if you can project that back with a variable-speed projector you can do really lovely stuff in the refilming. I did a lot of that in *Ecology* (2007), and that was the last time I used Super 8 extensively. We were refilming digitally this time, but forcing the digital frames down to three or six frames a second, so that there was a mixture of technologies in the digital doubling that was happening with the Super 8.

Sloane Square documented the domestic, making it sexy in a painterly way. And in *Gerald's Film* there is movement through the barn, then finding the lover's face: it seems like it's shot at three or four frames a second and then stretched out, from a continuous take for the whole reel. That film is an absolute portrait of love, and it's always searching for the frame. 'The personal is political' strikes me as a feminist statement; it's partly about politicizing the domestic realm in the public sphere. That's what Derek was doing as a gay man: he was putting his love into the public sphere – and to be a gay man at that point was a completely privatized sexuality. Legally it couldn't properly exist in the public domain, so that was an inherently political act, to be photographing with such a lusty and loving eye – love for his work, a love for life, for light, painting, photography and a love for these beautiful boys he was photographing. There's a synthesis of two things: the way he embodied the formal properties of that medium, and the playfulness of sexuality.

Sarah Turner *is an artist, writer and filmmaker. She has curated programmes at the Lux Centre, Tate and National Film Theatre. She is Director of Fine Art at the University of Kent.*

GARDEN OF LUXOR
1973

An imaginary garden made out of old postcards of Egypt, adorned with costumed figures and filmed through discarded footage from an old swords-and-sandals epic.

DEATH DANCE
1973

The back lot at Butler's Wharf provides the stage for a danse macabre, in which a sheeted Christopher Hobbs visits death on a group of naked young men.

...

SULPHUR
1973

Sulphur utilizes multiple superimpositions of fantasy and ritual, creating a dream world of rich textures and glowing colours.

A FRIEND INDEED
The Colourful Past

GINA BIRCH

#4

opposite **Journey to Avebury** (1973).

I came to London in September 1976 and shortly thereafter moved into a squat in Monmouth Road, off Westbourne Grove, in an area known as Bayswater. I used to commute to Alexandra Palace each day to study Fine Art at Hornsey School of Art. It was mostly a disappointing place, full of missed opportunities: there was so much space, yet I was given a tiny little desk at the top of a staircase, on a kind of narrow wooden overhanging balcony.

 The large environment I had imagined making, painting and living in was not possible, and I felt a bit like a fish out of water. My friends had dispersed to different cities, and I had only one Nottingham friend in London, but she lived with fashion students in Kensington in a very neat house, clean and fashion conscious, in the way only St Martins fashion students could be — they even had an ironing board up in their living room. I didn't yet own an ironing board, and didn't for many years after this. I had cold running water and, as Green Gartside recently commented about his experience in a Camden squat, I had a bath once a month, whether I needed one or not. I would cook on two gas rings I kept on the floor of my cupboard; they leaked gas and killed my only friend there, a rubber plant. Leaf by leaf it died, and they fell to the ground.

 I would walk along Westbourne Grove, with more than its fair share of rank-smelling charity shops, which of course I frequented, wearing their stinky clothes in wild and imaginative ways — the colourful striped orange and pink trousers that clung to my skinny legs, mohair jumpers with huge holes in them, galoshes, long drainpipe coats, my hair sticking up with the

help of melted sugar – and I'd go round the corner to bustling Queensway, where I caught two tubes and finally a bus, either the W2 or W7 at Finsbury Park bus station, to Alexandra Palace. I used to think, lazy and a bit hung-over, 'I've done a days work just getting here!' I used to go to the Roxy Club to see all the new punk bands and drink as much as I could afford. I was happy with the punk misfits but mostly too shy to talk to many of them.

One day I headed as usual for Alexandra Palace, and climbed the narrow staircase to the big studio that always stank of stale beer, it being located above the glorious Panorama Bar on the raised ground floor of Ally Pally.

That day the studio was mostly empty of people, and I made my way to the library, a largish room with old glass bookcases full of old art books. I picture the scene like a Renaissance painting, full of people arranged around the walls, low on the ground to high in the air, with the centre packed to the gills with people crouched on the floor: it was how I might imagine heaven from my Roman Catholic background, everyone surrounding God and the Holy Trinity. The light went off and then the most beautiful image shimmered in a squareish format on the wall. It was slightly blurry, it was colourful, it was reflective and it was totally beautiful. I think of smudges of colour, blurry flashes of light, a wobbly narrative and dreamlike, silhouetted figures dressed in beautiful, flowing garments and imaginative headwear – either something drawn on a cardboard box or a collage of feathers and felt. There were layers of meaning, enticing the audience to come in and bringing the outsider – me, you, his viewers – into its world. I think of Howard Hodgkin's paintings of evocative landscapes, known but unknown. Layers of different frame speeds overlap and merge, created through sunlight, fire and smoke. Glinting, flashing explosions of light merge with the blurry, smudgy landscapes and figures. Each frame of Derek's montaged films is capable of being as rich as any abstract painting, and with their ever changing beauty they have the ability to let the viewer fall into the beauty of this world, a world of imagination, make-believe, myth and magic. I knew at once that I was in love. I hadn't seen anything quite like this before and I was totally amazed. In Nottingham, in the film department, students were making films with scratches of colour or rhythmic blobs or something strangely mathematical and cerebral, and I thought it was modern and OK, but it left me rather cold.

The painter Stella Vine said that her drama teacher once told her that, when you see something life-changing, a moment of pure creativity that sets off a chain reaction in your heart and soul, you never need to see it again. You can experience it in your memory, and it could in fact be detrimental to see it again. I had one of these moments that day in the art school library at Alexandra Palace, a moment projected onto a white wall in a large room, with the beam of projector light and the sound of the projector intrinsic to the experience.

As a result of that day at Hornsey, I very soon bought a Super 8 camera. Within weeks I had spent £30 on a cheap brown bass guitar, which I took to pieces and spray-painted sparkly blue. Derek Jarman was a lifesaver for me, an inspiration in a dark and

thirsty time. He and punk were the mainstays of my creative life as a teenager and into my early twenties.

In *Journey to Avebury*, the golden colour of the sky is the result either of filters or of using Kodachrome or Ektachrome film outside. This film is created for artificial light and responds with too much yellow when filmed in sunlight, yet if the film set for sunlight is used in artificial light the resulting footage is unnaturally blue. If I used the wrong Super 8 film I would get a very blue or a very golden-yellow effect, and the reds would flash with glorious strength. I am very fond of mistakes; whether this was a mistake or not it was a beautiful result. The small, enclosed cartridges of Super 8 film that are reversal stock, which produce very saturated colours when there is enough light, are a mysterious and perfect medium for an open, experimental artist.

For some years I would see the world through Super 8 eyes: a group of children in black school uniforms with white collars running up a street in a village on a Greek island; sunlight glinting through trees; a child clamouring against a pane of glass; a boat trip round Manhattan on the Staten Island Ferry. In the 1970s I made several Super 8 dramas: a close-up of myself screaming for the entire length of a film cartridge, me jumping through giant paper screens, and, more recently, the burning of a hundred bras, music videos for bands, and part of my documentary about The Raincoats.

We now think of film and TV as the way of capturing reality. We are programmed to think of it as 'real'. But is it more real than the time before we discovered perspective, when there was an honest selectivity about what was considered most important? Derek's films introduce us to a different kind of reality, a world of the interior mind — feelings, thoughts and dreams — that impinges on our view of the exterior world.

Gina Birch *is an English musician and filmmaker, probably best known as a founding member of The Raincoats.*

JOURNEY
TO AVEBURY
1973

A landscape film saturated in gold that maps the great Neolithic stone circle and its surroundings at Avebury.

...

1

ASHDEN'S WALK ON MØN
1973

Ashden crosses the beautiful Danish island of Møn against the backdrop of a spiralling galaxy, all teased out in theatrical gels and slow motion.

DUGGIE FIELDS
AT HOME
1974

An intimate portrait of the painter Duggie Fields at home with his art.

MY VERY
BEAUTIFUL MOVIE
1974

Fire Island in New York, filmed and reimagined by Derek.

....

1

MAGIC & LOSS
Selective Blindness & Analogue Reality

MATTHIAS MÜLLER

#5

opposite & page 147 **In the Shadow of the Sun (1972–74).**

It is 19 February 2014, and Michael O'Pray reminds me on Facebook that it was exactly twenty years ago today that Derek Jarman died. I recall an evening only three months before his death, my last encounter with Derek, at the New York Film Festival, where *Blue* had its US premiere, with my (blue-tinted) film *Sleepy Haven* (1993) as the supporting film. The festival management had placed us in a loge, and I am still gripped by the hardly bearable image of Jarman, blind and close to death, bent over the railing and deeply moved by the endless standing ovation rising to his ears.

How could he not have been our idol? The radicalism of *Blue* seemed to me to be seamlessly connected to his early filmic oeuvre, both in its confrontation with the selective blindness of us all and in the provocative, personal tone of this work, which must inevitably compel a significant change in the prevalent notion of what we consider 'film' to be: you can be blind, and still be a filmmaker. In view of Jarman's subsequent blindness, there is an almost prophetic aspect in all the instances of blindness occurring in his films, such as the coarse, pulsing graininess of the dissolving Super 8 contours in his early oeuvre, the visual faculties of his figures hindered by facial masks, the eyelid of the dead Caravaggio weighed down by a coin. There automatically comes to mind an image of the blind seer endowed with special intuition and sensibility.

Jarman developed his work in the face of various menaces, crises and losses. Many of his films seem to pursue an unpredictable, meandering path between a melancholic

recognition of the impermanence of things and constantly new poetic revolts against that mutability. 'For our lives will run like / Sparks through the stubble,' murmurs a voice in *Blue*. The multilayered *In the Shadow of the Sun* (1972–74) already presents figures that seem to be perforated by this sort of spark, and whose glowing schemas provide the intimation of an ambiguous space behind the visible. I remember that the contrary motions of this film, as well as its unique colouration, inspired us at that time to make our film *Epilog* (1987, co-directed by Christiane Heuwinkel), in which the beginning and end coalesce. In particular, the dissolving contours of my film *Pensão Globo* (1997) seem to me to be a delayed response to Jarman's porous images. In my film, which contemplates dissolution and the permeable boundaries between life and death in sanguine colours, there are Jarmanesque floating superimpositions in which the figures and the world seem to become submerged. Derek's love of plants, expressed in the garden he defiantly planted against the backdrop of the nuclear power plant at Dungeness, as well as the concomitant hope of perpetuating oneself through their growth, resonates in the final sequence of *Pensão Globo*. In one moment of *In the Shadow of the Sun*, there are images filmed on screen from Ken Russell's *The Devils* (1971), for which Jarman did the set design; at the same time, the film transfers earlier Super 8 sketches by the filmmaker into a new composite film. In many of my early films as well, there is often a motif that a previous film has bequeathed to a subsequent one. In this way, some images are transformed into found footage through the renewed recourse to them in an altered context, and at the same time they make it possible for the sequence of different films created over a number of years to be experienced as segments of one single work.

During the early 1980s, my friends and I were part of a scene in which the decision to make films meant the choice of a certain way of life distinctly removed from the professional work of those filmmakers who sought to be part of the industry, and an equally clear avowal of fringe status. In Germany, for instance, the artistic centre of this scene was not Berlin, even if that loud-mouthed metropolis claimed this distinction for itself. Instead, films proliferated in the apartments, back courtyards, and run-to-seed gardens of smaller cities such as Bonn, Stuttgart, and Düsseldorf, and even my native city of Bielefeld. Upon his return from London, Padeluun lived (and still lives) a few houses away in my neighbourhood — 'an artist-mendicant with hollow Kafka eyes,' as Jarman wrote in 1984 in *Dancing Ledge*, 'who believes artists should work, take simple jobs, receive no funds from state or individual beyond what is necessary for the simplest existence'. Super 8 was the only medium that allowed us to live according to such strict ascetic principles and to produce films while having endless fun at the same time. To establish alternative forms of production and publication in a network of friends seemed the only possibility for overcoming what was certainly a noble but scarcely splendid isolation arising from the unremitting disregard

of these films on the part of festivals and the art world. Derek, a generation older, had an immense influence on us – directly through his films and writing, but also indirectly through characters such as the aforementioned Padeluun, who belonged to Jarman's circle of friends.

By the mid-1970s, the straight boys' club of structural cinema had withdrawn into an increasingly formulaic practice; the flowing cinema of Jarman, summoning total immersion and defined by chance occurrence, was also a defensive reaction against the academic avant-garde of those years, which remained as incomprehensible to him 'as if someone were to call water H_2O', as he once put it. Jarman's diverse references to the past, already evident in his selection of the medium of Super 8, a format that was supposed to allow the amateur to preserve precious private moments, stood in blatant contradiction to the obsessive insistence on the part of an ageing avant-garde that an unswerving focus must be maintained towards the new, the never-seen-before. If late structural film was also destined to look like a mopping-up operation to purge film of extra-filmic content, Jarman's cinema was always committed to the impurity of a medium that unabashedly absorbed ideas and effects from other art forms. In only a few other films is use made of concepts that refer to other art forms as frequently as in the films of Jarman: their painterly qualities, their poetry, all their alchemical transformations.

Just as I scarcely need to have absorbed the writings of Aleister Crowley to derive pleasure from the films of Kenneth Anger, so with Jarman's work I am not obliged to be familiar with pagan rituals or with Carl Jung's *Alchemical Studies* or *The Seven Sermons to the Dead*, which he used simply as the stimulus for – in his words – an 'ambient tapestry' made of 'dream images', which developed 'quite unconsciously' and were permitted 'to drift and collide at random'. His Super 8 films are above all visual emanations of his situation, interests and moods, inspired by, but not dependent on, the ideas of other people: they exude freedom and a delight in experimentation. Super 8 films were reversal films without negatives; with their dusty smudges and signs of wear-and-tear, they seem like an anticipatory affront to the glossy surfaces of the space-encompassing film installations that today abound in grand exhibition halls. In aesthetic terms, Jarman's Super 8 films had more affinity with the photographs of Nicéphore Niépce than with the films of his contemporaries. 'I am hopeless with machines,' he freely admitted, and the do-it-yourself mentality typical of punk also encouraged us, long before the instruction of art schools, to use simple consumer cameras, film after film, to assimilate a medium supposedly based upon undifferentiated specialization and a corresponding industrial, work-sharing procedure. Just like Jarman, we chose to be guided more by 'emotion and the pounding of waves', as the German Super 8 collective Schmelzdahin put it at the time, than by any sort of adapted prescriptions and regulations.

Today, many films situated in an artistic context make use of rules, production values, budgets and casts derived from

mainstream cinema; and in their conservative approach — particularly in comparison with the vibrant energy and provocative rawness of Jarman's early films — they seem to be singularly devoid of vigour. When young artists turn their backs on the new recording standard of visual representation and begin to discover analogue film for themselves, it often seems to be in the bloodless hope that, the medium being the message, the choice will by definition ennoble their work. Do the apps we use to apply the nostalgic effects of analogue photography onto our high-definition smartphone photos not constitute a similarly helpless endeavour to produce a unique, auratic copy amid the overabundance of images in our surfeited era? The art market has become open to analogue film installations, and the look and feel of their apparatus, and the sonorous hum of projectors, seem to help gallerists, curators and collectors encounter the eternal provocation of the motion picture with more equanimity, namely its evanescent, immaterial nature as time-based art. What would Jarman have said in that regard, that vehemently opinioned and sharp-tongued critic of culture, with his unerring recognition of every sort of inauthenticity, illusoriness and boastfulness? His voice is woefully lacking.

But Jarman's films are available. Revisiting *In the Shadow of the Sun* is an amazing experience. Just as impregnable and erratic as it was back then, it has also become a relic of a filmic counter-culture that to a large extent has been lost, and whose distance from us cannot be denied. Should this discrepancy not remind us of Jarman's own handling of historical material, in which he repeatedly rendered this distance productive, in a surprisingly unsentimental manner, as the subject of a contemporary artistic discourse?

Matthias Müller *is an award-winning German experimental filmmaker and curator who often works with found footage. He is Professor for Experimental Film at the Academy of Media Arts (KHM), Cologne.*

IN THE SHADOW OF THE SUN
1972-74

Derek created **In the Shadow of the Sun** *from a dozen different films entwined and superimposed one on top of another. It is his Super 8 masterpiece.*

SLOANE SQUARE: A ROOM OF ONE'S OWN
1974-76

Mid-1970s domestic life in Sloane Square culminates in a removal party to celebrate a forced eviction.

I am sorry for the disturbance on the screen. Derek says it is going to look like an earth cake Taff. all things have an and cat

CORFE FILM
1975

On the battlements of the Corfe Castle ruins, a begowned and bewigged Luciana Martinez awaits her knight in shining armour.

BEYOND LANGUAGE
At the Seams of Seduction

PETER FILLINGHAM

opposite **Sebastian Wrap** (1975). *page 177* **Gerald's Film** (1975).

Language, both spoken and written, is at times inadequate. This sense of the inadequacy of language is commonplace, but it can be devastatingly disempowering to find that one of our most important means of communication, of connecting and explaining, is no longer able to function effectively. Yet perhaps after the loss and the fear there can also be a sense of liberation; just as when travelling in a land where we do not speak or understand the language, we may feel freer to encounter people and experiences, no longer bound by familiar codes of language or behaviour. Something more intrinsic to us as human beings might emerge in such a situation: earlier, pre-linguistic modes of expression and communication once more become the means by which we negotiate the world. Having to learn another language or means of communication allows for the expression of differently nuanced emotions, feelings and encounters that perhaps can exist only in this 'new tongue'.

The process of watching and writing about Jarman's Super 8 films has, at times, struck me as similar to the realization that language can sometimes be inadequate. The viewer may well experience fear, perhaps frustration, and a wish to understand by relying on a well-known filmic language that turns out to be inadequate. Once a certain 'letting go' has taken place, an overwhelming sense of pleasure and liberation, a loosening of structures, occurs. With many different visions, there is a sense of being plunged into a world of sensuality, light, emotion, connections and associations, and also of film itself.

The short Super 8 film *Sebastian Wrap* begins with images I don't understand or cannot definitively recognize: an iris,

light bulb, a lens? Then I see a golden rectangle – a piece of gold leaf? Somehow its shape and shining surface speak of the ancient world, a ceremonial shield, an Aztec treasure. Yet something is between the rectangle and me, something that makes its shining surface flicker as though seen through water or changing light. Suddenly, in the edge of the frame, part of a human figure appears that I recognize in the same immediate way that as infants we apprehend the human form from the first moments our eyes focus on those around us.

As the shifting light and flickering continues, men naked and semi-naked, slim bodies bathed in the golden light of a hot climate, appear, and the square of gold leaf is in fact a real object, propped near where the men are lying and standing. For a moment one of the men becomes a silhouette moving against its shining surface. The men move languidly (it crosses my mind that the film is slowed down), and their naked bodies are eroticized by the light, but also by our inability to hold on to their image for more than a few seconds as the veil of light moves between the viewer and them.

For moments they disappear altogether, and the shimmering cloth or veil, or the effects of light on film, obscure them … I don't know what they are doing, but there is a sense of intimacy and I imagine the warmth of the sun on their skin.

I like the sequences in *Sebastian Wrap* in which there is a kind of rock-pool gazing, like Narcissus looking at his reflection. The portrait head is close-up, and a fanning movement blocks out the face and reveals it like a camera shutter. The superimposed activity is at times abstract and hazy, gazing at a scene from afar and yet still in control of the activities. The silhouettes are striking, as is the very hot weather and sunbathing.

The face of a young man appears closer to the camera. It is a cloth that moves between him and me. He smiles, and the wind that blows the translucent cloth ruffles his hair. Then he disappears. A silhouette on the square of gold leaf appears, the men reappear, naked and lying down. A man in trunks with a camera photographs them. The flickering continues, the cloth, a hand, the 'shield of gold'. Then, suddenly, the means by which the vision was created is revealed, as the film cuts to a long shot, a tableau, in which two semi-clothed men hold a cloth and the naked men lie on the ground in front of a stone wall, against which leans the 'golden rectangle' that is, now I see, a reflector for filming. One man in pale-blue swimming trunks is photographing the men, his back to us, the strap of a camera around his neck. I know this is not contemporary footage by the men's haircuts, the camera, the swimming trunks, even the men's physiques. The shimmering cloth through which we appeared to be gazing for most of the film blows in the wind; at the edge of the frame there is a blue sea; a man in white shorts kneels by the naked men, then rises and takes the camera from the man in trunks, and suddenly the vision disappears.

I am bereft. Just at the point of understanding, of grasping the image, of capturing the men in my gaze, of fixing a time and a narrative, the image disappears and I want it back.

In *The Pleasure of the Text* (1975), Barthes writes that the pleasure of reading de Sade derives from 'certain breaks (or certain collisions)' in the text, and suggests that what is erotic is the seam, the fault or the flaw. Later in the same book, Barthes asks, 'Is not the most erotic portion of the body the place where the garment gapes?' and continues, 'It is intermittence, as psychoanalysis has so rightly stated, which is erotic: the intermittence of skin flashing between two articles of clothing (trousers and sweater), between two edges (the open necked shirt, the glove and the sleeve); it is this flash itself which seduces, or rather: the staging of an appearance-as-disappearance.' The continual appearance and disappearance of bodies is replayed in the film's own appearance and disappearance as it moves between abstraction and figuration. I am seduced, wanting to view these images for longer, which appear between flashes of light or movements of cloth.

Of course, because of the film's title and because I have read about Derek Jarman and watched his movies, I can quickly assume that it was shot on location while he filmed *Sebastiane*. The film is, then, imbued with history: it is a historical document of Jarman's time filming on Sardinia, a record of an era, a moment of gay and filmic history. The setting of *Sebastiane* also links the film to a more distant past, as does the nakedness of the men, which evokes the Classical world.

Perhaps because of this, but also because of the landscape, the colours of sea and the gold light of the reflector, I am reminded of Pasolini's *Oedipus Rex* and *Medea*. In *Oedipus Rex* there is a scene where the infant Oedipus lies in his mother's arms, and from his viewpoint, through his eyes, we see leaves, sky and sunlight as the camera pans across the treetops. The screen is filled with light, with vision, the very thing that is taken from him later in the story. The film ends with a similar shot of trees, but one that falls down to fill the frame with grass, the ground where Oedipus will be buried.

Just as Pasolini's *Oedipus Rex* and *Medea* touch something deep in my imagination that I can access only at times, for fleeting moments, so does *Sebastian Wrap*. Surely it is more than this, something else – something to do with our collective memories, our shared pre-linguistic histories?

Sebastian Wrap is a kind of narrative, and a little like a home movie of a fragment of history once again, a valuable characteristic of Jarman's. The film also declares that it is one thing to make *Sebastiane*, but it is another to shout and say that 'It started with anger,' as Jarman once remarked. He profoundly understood the time and context within which he lived and worked. His vision was highly informed and researched, and, as he traced history, he sought an understanding of how things might develop and change.

Of his other works, *Gerald's Film* and *Ulla's Fete* have both influenced and guided me, and might be my favourites. They have provoked me to consider how best to respond to those around me, the things that we do and places that we visit. *Gerald's Film* unfolds in three stages. It begins as a fantasy, the discovery of a place in the forest. The painter takes a series of staggered photographic sequences that continually move

and pan across the spaces, and zoom in and out of the highly crafted architectural details, which remain unrestored and still, withholding their ghosts. The camera moves, objective and forensic, observing as the light changes and objects appear (why the straw-covered floor?). The film is not named after an imagined place, a mythical place, but after a man. This man is introduced; he appears quite friendly, sitting still; he is the muse. The player begins to follow the directions of the director, and walks and acts. Jarman then reshapes the film and places the player as part of the site, beautifully framed within the location. Ghostlike, as if he belongs to the place and is staying, Jarman is outside the building and looking in, framing and reframing with complete expertise as he constructs the finale.

Ulla's Fete is a tale of people getting on with it, together. Made in the mid-1970s in a private location – a garden somewhere in the middle of Hammersmith – it was, as Derek Jarman stated, a last gasp of the 1960s. Ulla, his good friend, had '"liberated", which was the correct word of that period', a chandelier from Harrods department store in London. She was caught and ordered to pay a large fine. At the garden fete, friends auctioned goods in order to generate enough cash to pay off the fine. The title was perhaps changed from *Ulla's Chandelier* or *Garden Fete*; we are left with *Ulla's Fete*, perhaps a play on her 'fate'.

Jarman stated in his voice-over of Super 8 film screenings at the ICA in London 'that there may be faces that you may recognize'. The screening of *Ulla's Fete* at the ICA was accompanied by the soundtrack of a Russian woman singing.

It is a statement of protest and group effort, a pulling-together to help a friend. For Derek Jarman, it was a small yet important moment of history: not charity, fundraising or merely giving or pledging money, but a record of action and pride. It becomes a very powerful reading of a moment past.

Written in collaboration with Dr Jonathan Whitehall.

Peter Fillingham *is a British sculptor, installation artist and curator. He is a former Head of Sculpture at Central Saint Martins and Chair of Fine Art at Parsons Paris.*

SEBASTIAN WRAP
1975

The last day of filming **Sebastiane** *in Sardinia. The actors sunbathe as Derek films them through a sheet of Mylar, which catches and obscures the image by turns.*

1

GERALD'S FILM
1975

An elegiac portrait of Gerald Incandela, filmed among the ruins of a decayed Victorian boathouse in Essex.

JORDAN'S DANCE
The Transmutation of Elements

NEIL BARTLETT

opposite & overleaf **Jordan's Dance** (1977).

Derek often referenced the signs and symbols of alchemy in his work — it was one of his points of contact with the Elizabethan world he loved and so often drew on in his writings and screenplays. I think his fascination with that world was much more than just theoretical. In some quite practical sense he really did believe in alchemy — in the principle of transmutation, and in the figure of the necromancer or conjuror, a figure whose combination of arcane knowledge and dogged practical experimentation often seems to provide the true archetype of his own practice as an artist.

Jordan's Dance, which started out as a Super 8 and then was enshrined in *Jubilee* in 1978, provides an illustration of what I mean (as well as being one of my all-time favourite film clips, ever). The figures who have been gathered to watch Jordan dance — or, rather, conjured to symbolically power and define the psychic space in which she is dancing — are clearly figures from some archaic manual, their names or exact iconography unknown and unnecessary to anyone except the man who has conjured them, that man being, in this case, Jarman with his Super 8 camera rather than John Dee with his volume of angelic conversations. Most importantly, by being filmed Jordan is quite literally transmuted from one element into another. The fire constantly smudges and distorts her dancing figure and also refines her; it takes the base elements of her too-heavy body and pure yet ludicrous ambition to dance like Fonteyn and transmutes them (via the crucible of the camera) into something that exists in a higher realm of purity, freedom and grace. Her hesitancy — her repeated attempts at gesture — make it clear that what she is

doing is not performing a routine or number, but willing herself to achieve this altered state. The camera is quite explicitly a functionary in that ritual.

The image is unforgettable — a haunting mixture of power and pathos. I love it not only for its intrinsic beauty, but also because it so bizarrely reminds me of one of the other greatest dance sequences ever filmed. Slow Ginger Rogers spinning out of Astaire's arms in 'Let's Face The Music And Dance' down to the jerky stop-go of Jarman's film of Jordan, and you will see a bizarre kinship between the two sets of images. There is the same paradoxical female physical solidity; the same floating white feathers; the same entranced yet almost frowning interiority.

Derek's achievement, of course, was to create the same level of disturbing poetry as Mark Sandrich for RKO, but in his own time — and to achieve it using not the resources of a major studio but with just a vacant lot, a few cheaply robed and unrobed friends, some burning garbage and the lowest-budget, most hand-held of technologies. Plus, of course, the instinct that lead him to a remarkable performer, and the generosity and intelligence that then let him license and free her to perform.

When I first saw this sequence — which would have been in 1979, I think — it poleaxed me, and every frame of it has stayed in my mind's-eye library. Its influence on me was very practical. Film wasn't — and isn't — my world, but seeing this sequence when I was twenty-one gave form and energy to all my own inchoate instincts about my own chosen arenas of performance and theatre. It showed me, in three haunting minutes, that roughness isn't antithetical to elegance, or anger the enemy of beauty; that economy and inspired improvisation on the level of production are better routes to true visual excitement (not to mention truth) than a big budget; and, above all, that what one is looking for as a director is the moment when a great performer — without knowing how, or even that, they are doing it — begins to transmute the world into something original. Oh, and how wonderful women are. It is, in every sense of the word, an extraordinarily inspiring piece of film.

Neil Bartlett *is a director and author. His theatre pieces include* A Vision of Love Revealed in Sleep, The Seven Sacraments of Nicolas Poussin *and* Or You Could Kiss Me. *His novel* The Disappearance Boy *was published in 2014.*

JORDAN'S DANCE
1977

Punk icon Jordan dances in a tutu around a bonfire of burning books.

5

ART & THE POSE
1977

Jean-Marc Prouveur and Gerald Incandela pose as George and the Dragon for Derek's camera.

7

2

B2 MOVIE
1981

A sumptuous, intimate record of 1981, as seen through Derek's lens.

3

1

WAITING FOR
WAITING FOR GODOT
1982

The essence of the quintessential Beckett play captured in rehearsal, as ghostly actors come and go.

.7

9

PIRATE TAPE
1982

William S. Burroughs, friends and passers-by filmed on Tottenham Court Road during The Final Academy event.

1

2

3

ICA
1982

Friends gather for the opening of Derek's first major show at the Institute of Contemporary Arts, London.

5

PICTURING DISSENT
Queer Experiments

ISAAC JULIEN

opposite & page 237 **It Happened by Chance** (1972–83).

I first encountered Derek Jarman's work in 1976, when I went to see *Sebastiane* at the Notting Hill Gate cinema. I would have been sixteen, having to pretend that I was eighteen. Later, when *The Tempest* (1979) came out, my friend the fashion designer and milliner Paul Bernstock performed in the sequence where Elizabeth Welch sings 'Stormy Weather'. In the early 1980s I was personally introduced to Derek at screenings of his Super 8 works at the London Filmmakers' Co-Op, and in 1982 at St Martins, where I was studying fine art film. I knew him through clubs like The Bell and Traffic. He was already quite established as a gay icon.

At St Martins, Derek showed *Jordan's Dance* and *Tarot*, among others, and I also went to his screenings in shows at the ICA and the London Filmmakers' Co-Op. His Super 8s were often projected with vinyl records, usually operatic, providing an informal soundtrack.

A collective sensibility, largely inspired by Derek's style, developed in the early 1980s within a school of filmmakers and artists. They invested their hand-made Super 8s with a pictorial aesthetic, achieved by slowing down the speed of the projector and increasing the film's duration, which lent a dreamlike quality and a painterliness to the images. It was a moment of extreme experimentation: working across different media; transferring the different filmic textures of Super 8 onto 16mm film and video; exposing the grain and revealing the materiality of the film itself.

Derek's school – in which I saw myself as a fellow traveller – was directed against the more formalist, structural/materialist works that were mostly associated with the London Filmmakers'

Co-Op and had began to be used as the benchmark for experimental film. An orthodoxy had crept in, which we rebelled against. We regarded Peter Gidal's films, for example, as classic structural/materialist. A younger generation of video artists and experimental filmmakers – Constantine Giannaris, John Maybury, Cerith Wyn Evans, Stephen Chivers, Anna Thew, Sandra Lahire and Jean Matthee, to name a few – were interested in very different issues based around identity, music videos and gay sex. Though indebted to structural films, there was a need for a new, more lyrical language to address questions of desire and sexual representation. Super 8 was a very accessible medium that lent itself to experimentation.

There were some lyrical experimental films made in the 1960s and early 1970s, so perhaps the divisions and oppositions were not as absolute as one thought. For instance, Malcolm Le Grice's *Berlin Horse* (1970) is very beautiful and different. But there was a strong divide in the way that people argued for legitimacy, which was connected to funding as well as different theoretical and political positions.

The new approach was quite sardonic. There was a provocation in sexual dissidence and the way it formed its own aesthetics. One could say that these were the beginnings of a queering of experimental film, of which Derek was always at the forefront. Of course, there have been several attempts to contest or intervene in the culture of experimental film, some of which manifested themselves in the 1985 Cultural Identities conference at the Commonwealth Institute, organized as an encounter around questions of 'race' and experimental film, in which I participated as a member of Sankofa Film and Video Collective. The conference was presented as being about 'identity', but actually it focused on questions of form and politics.

Generally Derek sidestepped these discussions. He enjoyed exploring themes in the 'doing' and the 'making' of the work. He was very learned; he had studied English at King's College London and taken a second degree at the Slade, where he drew on his literary background with experiments on film. He brought an English romanticism to experimental film – references that harked back to John Dee, the English Enlightenment and William Blake, in whom Derek was extremely interested. In his Super 8 films he constructed images in a really extraordinary manner: they had an aesthetic sensibility that was achieved through a technical precision that was also extremely seductive.

Derek took gay sex, and a lyrical representation of it, for granted, but parts of the gay community could be quite conservative in their response to his political lyricism. I remember going to see *The Last of England* in a West End cinema and thinking that his themes linked up with some we were treating in the Black film and video collectives at that time, although we came from different positions of class and race: I was critiquing Englishness from the outside in, while Derek was critiquing it from the inside out.

Once I went to the old Lumière cinema in St Martins Lane, where Derek was viewing tests for *Caravaggio*. He told me that he was able to present work in the cinema because of financial

help from the British Film Institute and his connections with producers such as James Mackay, who could facilitate experiments such as transferring a Super 8 film aesthetic to 35mm. The arts community was a big supporter of his.

I also remember going to the Berlin Film Festival in 1985, seeing films like *The Angelic Conversation* and sensing the impressive public support that his work received in Germany. At that particular time, Berlin felt like a centre of gay European culture. A very active community respected and encouraged Derek's work, whereas in Britain he was much more contested, a situation not helped by the Conservative government's policies. I learnt from Derek that it was very important to create audiences for your work outside of a British context.

Everything Derek made was for the big screen rather than smaller projection. I took a lot of my instruction from him; there's certainly no way I could have made a film like *Looking for Langston* if Derek hadn't made works like *Caravaggio*. I felt an energy in these films that linked back to earlier iconic gay directors — Jean Cocteau, for example. There was an excitement and confidence about cinema that Derek often took for granted, but that we cherished.

Queer political culture evolved as a way of trying to oppose Thatcher's deeply individualist philosophy (she had claimed that there was 'no such thing as society'.) Laws were being made to control our existence and to prevent us from being ourselves. At the same time, our lives were threatened because of AIDS. You had to make strong work to challenge such positions.

I attended a Super 8 film festival in Norwich in the mid-1980s. Super 8 was its sole focus: people exchanged and showed Super 8 films for several days, and the fact that enough people were making Super 8 films to form a culture and hold a festival seems quite astonishing. In 1983 I even began shooting *Territories* on Super 8, such was Derek's influence. There's something about the materiality of Super 8 film, about the way you can still transfer it to film to keep it alive, together with the screenings and discussions, that helped maintain a community of interested people. Derek created a world that documented a unique vision of a culture: one in which artists were able to explore aesthetic questions connected to desire and politics. Maybe his Super 8 films were his finest works.

Derek spearheaded a movement. There was, however, a slow march of conservatism that pulled resources away from these dissenting voices, making it very difficult for people to oppose the status quo. Sources of funding for such activities were closed down, and one had to be very adept at circumnavigating those obstacles to survive. When the YBAs came into existence with an institutionalization and commodification of the art world, the spell of the art market took over and the independent, experimental Jarman school of film was finally killed off.

After Derek's death there was a kind of revival in experimental film, when the London Filmmakers' Co-Op moved to Hoxton Square and became the Lux Centre for Film, Video and New Media. It took time, but an audience did grow and, with some of Gregor Muir's work, a momentum began to build, especially

when White Cube opened in the same square. In 2002 the Lux collapsed financially: it retreated into film and video distribution and the running of seminars, but lacked a cinema space. With no means of exhibition, the works I have been discussing would simply stay in the archive. In my own practice, with films such as *Looking for Langston* (1989) or *Frantz Fanon: Black Skin, White Mask* (1996) I have long been interested in activating archives as way of creating intergenerational dialogues. I had this in mind when Colin MacCabe approached me to make *Derek* (2008). At first I thought the project was impossible, but after watching Colin's twelve-hour interview with Derek I was hooked. I knew straight away that, in order to stay true to Derek's interdisciplinary spirit, there would have to be several parts to the project. In the end, I made the film with Colin and Tilda Swinton, and curated an exhibition at the Serpentine: *Derek Jarman: Brutal Beauty*. I always envisaged the film as part of the exhibition, performing a pedagogic function, like a curatorial prologue to the catalogue. I conceived *Blue* as an environmental installation rather than a conventional screening, updating Derek for a new generation.

Another installation was based on *It Happened by Chance*, a work that I first read about in Tony Peake's biography of Derek, and of which James Mackay showed me a version in my studio. It consisted of a three-screen film that had been shown at the ICA in 1976, the Hayward Gallery in 1977 and St Martins in 1982, while I was an art student. I decided to work with Tom Cullen, my installation technician, and Catherine Gibson, my studio production manager, to develop a ten-screen version, simply entitled *It Happened by Chance Redux* (2008). Formally, it replicates a salon hanging of Derek's black paintings at the Richard Salmon Gallery in South Edwardes Square in the late 1980s, with the original *It Happened by Chance* submerged in a tableau of what I regard as Derek's most important Super 8 films. The screen sizes differ according to the film's colour and textural qualities, so the landscape films are on larger screens, and portrait films on smaller screens, all of which are angled to create an unusual environmental framework and add a sculptural dimension. The intention of this assemblage is to create a sublime meditation, a portrait of a lost London art world. The installation deliberately conflated his painting, major film works and Super 8s.

Twenty years after his death, Derek is much more recognized than when he was alive.

Isaac Julien *is an installation artist and filmmaker. He is Chair Professor of Global Art at Central Saint Martins, University of the Arts London. A nine-screen installation of his work* Ten Thousand Waves *has been shown at the MoMA Atrium, New York, and in sixteen other countries.*

**IT HAPPENED
BY CHANCE (1–12)**
compiled 1972–1983

*All the odd bits, the fragments, that didn't quite fit into a finished film:
a tapestry of colour and movement spanning one decade.*

3

BACON	EGG	SA...
STEAK	BACON	E
SAUSAGE	EGG	
PUDDING	BACON	EG

24

253

254

255

256

260

261

262

263

264

266

268

27

71

27

ANGELIC CONSERVATION
A Technical Overview of Archiving & Restoration

**JAMES MACKAY, Curator
& TOM RUSSELL, Colourist & Grader**

James Mackay The brown, military suitcase that Derek entrusted to me, with 'JARMAN' stencilled onto the lid, contained 110 separate reels of film — some labelled, many not. This collection comprises all of the Super 8 film work that Derek made between 1970 and 1983. On examination, there were found to be about eighty individual titles, twelve reels of compiled footage (*It Happened by Chance*, reels I to XII, and Derek sometimes would assemble one film on top of another to free up a spool that he needed for a work in progress) and various other fragments. The archive is made up of original Super 8 reversal films, the reel of film that passed through the camera being the same one that was edited and projected.

Super 8mm film was Derek Jarman's primary medium in the 1970s, but by the end of the decade he was acutely aware of its fragility and had largely stopped screening it. In the early 1980s he made 16mm copies of a handful of titles, including *In the Shadow of the Sun*, which was presented at the Berlin Film Festival in February 1981. He also made video copies of twenty-one titles as a series for screening at an ICA season, and Michael O'Pray had Super 8 copies made of some of the films that he then toured in the US. These became the titles listed in all published filmographies; the others were forgotten.

Having responsibility for the archive, I set about finding the best way to preserve it. I had begun working with Derek's Super 8s in 1980, and over the following eighteen years I managed to have 16mm negatives made of seven of the films. In 1982 four of these negatives were copied; they now rest in the National Film and Television Archive. In addition, 16mm prints of three

other titles can be found in the Centre Georges Pompidou, Paris and the Pacific Film Archive, Berkeley.

In the 1980s I managed to transfer around 70 per cent of the material to video of a good standard – first to BetaSP and later to DigiBeta. This helped to keep most of the films in public view, but it didn't solve the long-term conservation needs of the complete collection.

As time passed, I became increasingly worried about colour fading, particularly in the early Ektachrome material, and realized that I needed to copy it to another format. There were two possibilities. One was to copy the material to 16mm or 35mm film. Past experience with 16mm told me that a certain amount of distortion seemed to creep in. I had seen some very good transfers to 35mm, but none were made in the UK. In any case, the cost of transferring a whole archive to 16mm or 35mm was prohibitive. The second possibility was to digitize the images. I knew that 2K digital scanning for Super 8 was possible in London and that it would result in very high-resolution copies of the films. In order to see what could be achieved, I selected *Tarot* from the archive, partly because of its red/black sections, since the accurate rendition of red had always been a problem in earlier transfers to analogue videotape formats. I scanned the film with Tom Russell at Prime Focus. The results were stunning. The clarity of detail was far greater than I had been able to achieve with transfers to 16mm and professional Telecine, and the red was clear and limpid.

The best way forward would be to make 2K scans of the whole archive, then keep the original Super 8 films in deep cold storage to allay further deterioration. The next decision was to ascertain the best storage medium for the digitized archive. There was also the question of 'look and feel': I did not want to change the way that the image appeared on screen. The 2K process produced a transparent result, with no trace of digitization, but it was a bigger, brighter image than the one archived through projecting the original films on one of Derek's small Bolex projectors. I took the pragmatic approach that 2K digitization would result in an image closer to that seen by Derek through the viewfinder, not clouded by the relatively primitive projection system available for Super 8 at the time. Knowing Derek, I am certain that he would have preferred the larger, clearer image made possible by the scanning process.

In 2008 Isaac Julien included a selection of the Super 8 films in the exhibition of Derek's work that he curated at London's Serpentine Gallery under the title *Brutal Beauty*. It was there that Maja Hoffmann, founder of the LUMA Foundation, saw the films and offered to fund a conservation programme to preserve them and to make them more generally available.

A four-year programme was instigated to create a fully accessible high-definition scan copy of every frame of the archive, for exhibition and study. After long deliberation, it was decided to make four types of copy: a 2K master scan backed up to LTO (with the grading information stored on separate files); a set of HD Cam SR 4:4:4 tapes of the graded films; a set of Blu-ray discs corresponding to the HD Cam tapes; and a set of SD DVDs with burnt-in time code to act as a visual

index for the HD Cam tapes/Blu-rays. As Derek's films run at a variety of speeds, the master transfers were carried out at 24fps, which allowed finer precision when rendering each film at its designated speed. Greater accuracy is the key here, since the 18, 12, 9, 6 and 3 on the projectors' dials are indicators of speed rather than empirical facts. This was one of the reasons that we decided to store the images as raw scans with grading information (and any fixes that were applied for bad splices or juddering caused by warp): so that our decisions could be revised in the future.

The material first had to be examined and prepared, a process that I undertook alongside filmmaker and Super 8 specialist Gunter Deller, who arrived from Frankfurt with a set of Super 8 rewinds and a huge roll of white leader. (When you scan or Telecine, you need to have a long run at the front and end of each reel to stop it coming off before the last frames have been through the aperture.) Working with a loupe and a light box, we carefully checked and logged each film, repairing splices where needed and assembling the shorter films onto larger compilation rolls for ease of scanning.

The films were then taken to Tom Russell, the colourist and grader, who had worked closely with Derek and me on the transfer of Super 8 film for his features *The Last of England* and *The Garden*, as well as the Super 8 films in the archive. Having previously transferred the bulk of the Super 8s to 16mm and 35mm when Derek was still alive, he had direct knowledge of Derek's intentions regarding colour.

Tom Russell My job began when Maja Hoffmann stepped in to enable the conservation of Derek's Super 8 films, since there were questions about their future viability. Kodachrome is the most stable, along with black and white; the problems all seem to be in the area of Ektachrome and other tri-pack emulsions. We knew that the Ektachrome was deteriorating, and that its colours fade quite dramatically even if you just leave it in a drawer, so the project had to get under way quickly. James brought me the examined material with the weak physical edits remade and, where possible, joined on larger reels, so that we could scan a decent length at a time and didn't need to stop to change every small piece of film.

One of the issues that came up is that different film stocks are of varying thicknesses, and Derek often mixed stocks on a single film. In hindsight, it would probably have been easier to join the films by stocks rather than by year or subject. We tried to keep them historically accurate, which was probably not the most practical approach. Black and white is considerably thinner than some of the colour formats, and the focus changes depending on the thickness of the film, meaning that the scanner sometimes had to be refocused between pieces of film. Where Derek himself cut colour and black and white together, there was no getting away from the problem.

The scanning was done on a Spirit 2K, a fine machine and, I think, the only choice for scanning Super 8 at sufficient resolution. When the Spirit first came out, it had a 35mm and a 16mm/Super 16mm gate, but none for Super 8mm; it was only

after badgering that Bosch, its manufacturer, modified the 16mm gauge to run Super 8mm as well. It was a customer demand (they never thought it would be necessary), but I certainly transferred a lot of Super 8s over the years.

Super 8mm film is very small, which makes handling it difficult, to say the least. It's the original, so any damage done to it is permanent, and it is old film. You have to try to keep it in the right atmosphere, with controlled temperature and humidity, and treat it very, very carefully. The film was scanned onto our central storage and backed up on a hard drive, so that it always existed in at least two places. It was then scanned as 2K 10-bit log DPX files, which are more than capable of holding all the information on a frame of Super 8. The image sequence was then transferred from network storage into our Baselight grading system, where it was graded at 2K on a Barco projector. It was at this stage that many of the problems with the age of the film became apparent. Because both James and I had worked with Derek on the films, and had reference tapes that represented Derek's ideas and wishes when the films were made, we knew up to a point what his intentions were, but when we felt that something could have been done better and that it was something he would have done, we didn't feel bound to stick to the letter of the law. We never strayed far, but I think the job benefited from those improvements.

For instance, on *Journey to Avebury*, where Derek hadn't adjusted the camera for the light loss caused by his yellow filter, he'd always been disappointed by the image's darkness. I was able to return the film to the correct luminescence, so that the images were clearly visible instead of being obscured by a dark yellow fog. Derek edited with pre-made tape splices and a tape splicer at that time. Some of the edits had stretched, some weren't quite correct, and one of the splicers he had used cut the film at strange angles, which caused it to bump through the gate on either projection or scanning. It was not possible to remake those edits, since sections of film had been removed and there would be gaps. In such cases we were able to cut some of the frames out. Although this changes the films marginally, it does make them run much better.

Derek was very good at handling film. He hated it to be dirty or damaged, and I think those early splices were a big disappointment to him when the film bounced through the gate of the projector or the Telecine. He was always trying to find better ways of doing things. It's interesting to see the progression of splicers or editors through the films: at the end he was achieving cement splices, which is no mean feat on film half the width of your thumbnail.

There are one or two reels of film in the archive that we quickly decided weren't attributable to Derek. When we viewed them it was obvious, and we knew immediately that Derek wasn't holding the camera. There was one shot in Hyde Park that was quite clumsy and seemed to be trying too hard to be avant-garde, trying too hard in general.

My Beautiful Movie, which was largely shot on Fire Island and Long Island in America, was quite a revelation. There were two seemingly separate films, but the first one was blighted by dust

and hairs and was an experiment in superimposition, and the second was almost identical, except that Derek had learned from his mistakes and was getting it right. This also applies to the *Art of Mirrors* sequence, where there are many attempts and false starts before it finally comes together.

Recolouring the faded images of the substandard film stocks of the 1970s, such as Ektachrome, required a lot of grading, which is not normally needed for Super 8. It was mostly the greens that had vanished, so you started by making the picture green overall, or the colour you were restoring, and then you pulled that colour back out of the areas where it was not supposed to be, predominantly the blacks. Very often it took a lot of keying to clean up the blacks and whites just to get enough colour into the mid-tones — for example, the bright petals of a flower — without all the blacks going green. This problem was exacerbated by the way Derek often cut his films: when you had a full-colour Kodachrome section beside an Ektachrome section, the latter looked even worse than it was. It was quite a struggle, but having seen the digitized films projected many times I think the results are very pleasing. This quality would not have been achievable if it had been done optically, without modern digital grading tools that split away different parts of the picture according to luminance and colour that can then be manipulated separately. To have tried to do the same even a decade earlier, by optical means, would have been an immensely expensive and drawn-out affair.

Another part of our work is judging the correct running speed. Some of the films run at very strange frame speeds — 4 frames a second, 6 frames a second — although they might have been shot at 24 frames a second, which slows them down immensely, but that's how Derek wanted them to be. He might have labelled the can '12fps', but he might also have adjusted the projector while the film was screening to whatever speed he felt suited that film, or part of the film, at the time. Some of the films, the *It Happened by Chance* series, were just left running in the background rather than in front of a fixed, seated audience. He set music to play along with them, so that they were part of an experience rather than the only experience on show. He used to change the speed settings on his projector so that, no matter what speed the film was shot at, he would display it at a completely different frame rate, and you've got to try to work out which frame rate to run your grading machine or your player at to emulate what he was originally doing. We scanned all the film at 24 frames a second, frame-for-frame, and from that we can change frame rates or go anywhere we want without spoiling the film.

For the film to be digitized, it goes through a gate that basically consists of lenses and a strong light source directed down through the lenses and through the film onto a CCD (charge-coupled device) at the bottom. This captures the electronic impulses of the light being shone on the film, and all the nuances between the different colours and levels of brightness. The size of it on the spirit, pixel-wise, is 2048 × 1556, which is pretty square. It's not widescreen but, as luck would

have it, it suits the shape of the Super 8, which is not far off. We scanned all the film at that size, which meant we captured all of it, even a bit of the sprocket hole.

Super 8 was made to take maximum advantage of the film's width, so the height has to be connected to the width otherwise people will be long and thin or short and fat. The actual aspect ratio of Super 8 film is a bit of a mystery: I've looked it up several times, but it's a really weird series of numbers, it's not easy to remember.

We graded using Baselight. The files made from the scan were ingested into and graded within the Baselight, then output to the chosen format – LTO for archive, hard drive for use, tape. We never actually touch the raw data: we modify it within the grading grade and then output that modified data, keeping the raw data untouched so that, in terms of the archive, the raw data and the metadata are separate and can always be recombined at another time. It allows for future adjustments. The nature of the films is such that they're not going to be just projected in cinemas with perfect viewing conditions. They'll often be shown in galleries with light coming from all sorts of directions, so it is quite conceivable that each viewing environment would need its own set-up and its own grade. A little more contrast here, a bit more brightness there can make a great difference in a well-lit room as opposed to a dark cinema environment. Should better machines emerge, better techniques of cleaning up the faded film, each data set can be revisited. At this point in its life, the important thing was to get the film scanned so that we could take all the information that was left on the faded stock and preserve it. We have, to the best of our ability and with the best technology available today, stayed as close to the original as we can. Who knows what may happen in the future.

I worked with Derek at the second peak of his involvement with Super 8, around the time *The Last of England* was made. It was a much more exciting and free-form experience than working with other filmmakers. Derek would set up a scene and give people a camera, and the nature of Super 8 meant that you could afford to have several cameras there. The results could be quite abstract but were always very interesting, and put into the hands of a good editor they made fascinating films.

With a traditionally made film, it would be cut then graded at the lab, and only then would the director be involved. But Derek's involvement was crucial right at the beginning because that's when he set the look, and his grading was done in the Telecine as soon as the rushes came in. The film was cut on tape and transferred back from tape to film, making it one of the very earliest electronically made negatives around. Because of the complex, layered nature of his edits, it was very difficult to change the look later if he didn't like it. It's not as simple as with modern digital machines, where you can separate all your layers and look at them one by one. Once it was hard-baked in, unpicking it would have been a major job.

The electronic Telecine process gave him a chance to experiment. Derek had tried Paint Box and other high-end production tools that were coming on stream then, but never

thought to use them in his films. With Paint Box, he'd wanted to use a pen to write on the image, which at that time was completely impossible. With Super 8, he could use a black glove and a film camera to do the lettering, and he liked the immediate contact. He still loved the look and feel of film. Although he experimented, he didn't turn to video cameras immediately. I think he saw the Telecine as part of the shooting process, of creating a look, rather than belonging to post-production, as it did with Paint Box.

With Derek's Super 8 impositions, the process was still very much about shooting something, reshooting it, sending it off to be processed and looking at it each time. The great thing about the electronic method was that you could view films within a few minutes — that's what he really appreciated — rather than having to send them off to Germany (or wherever it was at that time) to have them processed, and not really being sure what you had until you got them back.

Sometimes it was hard to know what Derek wanted. You'd offer up numerous effects and occasionally you'd strike lucky, not really knowing why it was the seventh suggestion that he loved and why idea six hadn't been correct. He fell in love with looks very quickly once he saw them, and generally he was very right. I have to say, looking back at the looks he chose and that we achieved, they are stunning. When you see the final film, it's surprising how those disparate images come together so well. Sometimes the film appeared to be random and rather chaotic, but it would have a channel, and in the end would be cohesive.

There wasn't a storyboard as such, and Derek was always willing to experiment whichever stage you were at, but he wouldn't embrace anything just because it happened to be new and different; he was selective. He could be quite conservative; perhaps that came from the five years he spent between 1970 and 1975, developing films that eventually became *Sulphur* and *In the Shadow of the Sun*, which are very complicated and involve a lot of grading because he would use coloured gels. He seems to have been able to carry that process over into the much more formal environment of the editing suite.

In a sense, I was the cameraman and Derek was the director. He would always have an idea about where he wanted the film to go, and the relationship was similar to the one you might have with a cameraman, discussing an idea and trying out different looks to arrive at the right one. It's a growing process, an organic one: you start in one place and end up somewhere completely different, but on that journey you've covered a lot of ground and created lots of different looks on the way. It was always an enjoyable process. I think work wherever possible should be fun, and it was always a good day at work when Derek was there; he was a very nice man.

FILMOGRAPHY

I have based this filmography on the one published by Tony Peake in his biography *Derek Jarman* (London: Little, Brown, 1999). The dates given after each title are Peake's. Several previously unrecorded titles have come to light since then, and these are now included. I have also given other information, written in Derek's own handwriting, that appears on the film cans, although it appears that in some cases, the dates he inscribed are actually incorrect. Derek had a habit of changing the titles of his films from time to time, so many have alternative ('aka') titles, which are also listed. In most cases it is impossible to say which came first.

The two projectors that Derek possessed were capable of running at various speeds – 3, 6, 9, 12 or 18 frames per second – and he would often change speed during the projection of a film. During conservation, running speeds were matched wherever possible to those of existing projection copies, while others were based on speeds written on the individual film cans. The actual speeds of Derek's projectors are only approximate. The times given here are taken from the digital copies, whose running speeds are absolute.

Derek would change the accompanying music from time to time, so the tracks listed below are a guide only. Examples where music was specially composed for a film (such as *Sloane Square: A Room of One's Own*, composed and performed by Simon Fisher Turner) or added at the edit stage (*T.G.: Psychic Rally in Heaven*, from the album *Second Annual Report* by Throbbing Gristle) are indicated.

At Low Tide, 1972
aka **The Siren and the Sailor**
colour, 6min 53sec
filmed by: Derek Jarman, Marc Balet
featuring: Andrew Logan, Bente Lohse
costumes & props: Christopher Hobbs
location: Dorset coast
music: Maurice Ravel, *Daphnis et Chloé* (M. 57)
notes: '*July 1973*' on can.

Studio Bankside, 1972
colour and b&w, 6min 47sec
featuring: various friends
location: in and around Derek's studio (now demolished) at Bankside, London.
music: Edward Elgar, *Sea Pictures No. 2: In Haven (Capri)* (Op. 37)

Haircut (Self-Portrait), 1972
b&w, 5min 2sec
notes: front title in Derek's handwriting, in the same style as those found on *Studio Bankside*: 'a self-portrait filmed for me by Mike Davies'.

I'm Ready for My Close-Up, 1972
colour, 6min 25sec
filmed by: Derek Jarman, Marc Balet
featuring: Gaby Chautin
design: Andrew Logan
music: Roberta Flack
notes: labelled '*May 1972*'.

Andrew Logan Kisses the Glitterati, 1973
colour, 9min 26sec
featuring: Andrew Logan, Manolo Blahnik, Eric Boman, Duggie Fields, Jenny Galer, Christopher Hobbs, Gerlinda von Regensburg, Peter Schlesinger
music: Lou Reed, 'The Kids'

Andrew, 1973
colour, 8min 34sec
featuring: Andrew Logan
notes: '*May 1973*' inscribed on film can. Andrew Logan bathes, gets dressed and goes out.

Red Movie, 1973
aka **Tourist Film**
colour, 9min 17sec
location: Kew Gardens, Kensington Gardens and the greenhouse in Derek's studio at Bankside, London.
music: Serge Gainsbourg
notes: filmed through a red filter. '*May 1973*' on can.

Stolen Apples for Karen Blixen, 1973
b&w, 2min 16sec
featuring: Gerald Incandela, unknown man
music: Claude Debussy, *La Mer* (L. 109)

Miss Gaby Gets it Together, 1973
aka **All Our Yesterdays**
colour, 3min 8sec
notes: a shortened version of *I'm Ready for My Close-Up* made by refilming parts off the screen. In many ways it is a companion piece to *Miss World Pink Version Final* and *Burning the Pyramids*, which are all shortened versions made by refilming projections of the originals.

Gerald Plants a Flower, 1973
b&w, 1min 35sec
featuring: Gerald Incandela

Gerald Takes a Photo, 1973
b&w, 2min 10sec
featuring: Gerald Incandela

Tarot, 1973
aka **The Magician**
colour, 7min 39sec
featuring: Christopher Hobbs, Gerald Incandela
location: Christopher Hobbs's bedsit, Islington, and Butler's Wharf back lot, London
music: Johannes Brahms, *Violin Concerto in D major, Allegro non troppo* (Op. 77) (ICA compilation, 1981)
notes: '*July 1973*' on can.

Shad Thames Home, 1973
b&w, 4min
notes: filmed in the autumn of 1973. It begins with 'My Own Tea Shop' then shows the studio, river views and the back lot where *The Art of Mirrors* series was filmed.

A Garden in Luxor, 1973
colour, 10min 33sec
notes: a single-layer edited film used as a base for *Garden of Luxor*.

Garden of Luxor, 1973
aka **A Garden in Luxor**
colour, 8min 24sec
featuring: Alasdair McGaw, Christopher Hobbs
music: Nico, 'We've Got the Gold'
notes: '*August 1972*' on can.

Kevin Whitney, 1973
colour, 2min 34sec
featuring: Luciana Martinez, Kevin Whitney
notes: '*summer 1973*' on can. Kevin Whitney paints a portrait of Luciana Martinez.

Beyond the Valley of the Garden of Luxor Revisited, 1973
colour, 58min 59sec
music: Terry Riley
notes: '*Sphinx Fire September 1973*' on can.

Burning of Pyramids, 1973
aka **Burning the Pyramids; The Art of Mirrors; Burning of the Pyramids**
colour, 32min
featuring: Kevin Whitney, Christopher Hobbs, Luciana Martinez, Gerald Incandela
music: Maurice Ravel, *Piano Concerto in G major* (M. 83), 2nd movement; later Edgar Varese. In 2010 Max Richter composed and performed a suite of music for the following films: *The Art of Mirrors* (short version), *Ashden's Walk on Møn*, *Tarot* and *Sulphur*

Death Dance, 1973
colour, 15min 27sec
featuring: Christopher Hobbs as Death, Gerald Incandela, Tim Spain, Robin Wall, Kevin Whitney
location: back lot of Butler's Wharf, London
notes: '*Sept 1973*' on can.

Arabia, 1973
colour and b&w, 78min 35sec
featuring: Penny Jenkins
notes: '*May 74 revised version 75*' on can.

Sulphur, 1973
colour, 15min 15sec
featuring: Graham Dowie, Christopher Hobbs, Derek Jarman, Luciana Martinez, Kevin Whitney
music: Cyclobe later composed soundtracks for *Sulphur*, *Tarot* and *Garden of Luxor*, which were premiered at Meltdown in 2012
notes: this film may have been completed later, perhaps after *In the Shadow of the Sun* in 1974 or 1975.

Journey to Avebury, 1973
colour, 13min 29sec
music: Maurice Ravel, *Pavane pour une infante défunte* (M. 19)
notes: filmed through a yellow filter. 'July 1973' on can. A soundtrack by Coil was added in 1995.

Walk on Møn, Denmark, 1973
b&w, 19min 40sec
notes: 'September 73 First Version' on can.

Space Travel, A Walk on the Island of Møn, 1973
colour, 19min 50sec
notes: a re-working of material shot on his trip to Denmark.

Ashden's Walk on Møn, 1973
colour and b&w, 37min 38sec
featuring: Ashden (surname unknown) and others
notes: the last of a series of films filmed on the island of Møn off the coast of Denmark.

The Art of Mirrors, 1973
colour, 49min 18sec, in three parts:
1. *Burning the (triangle) "Art of Mirrors"*
2. *By the Sun's Shadow "Art of Mirrors"*
3. *Fire Film "Art of Mirrors"*

Shad Thames, 1973
colour, 23min 26sec
notes: a home movie of domestic life at Butler's Wharf, filmed by Gerald Incandela.

Café in Tooley Street, 1973
aka *3 fragments of diary*
b&w, 3min 5sec
location: a café near Southwark Cathedral, London

USA XII TVA, 1973
colour, 3min 38sec
notes: close-ups of shop windows and other details of New York filmed in lush colour.

Miss World, 1973
b&w, 28min 6sec
notes: 'Nov 73' on can. Documents the second of Andrew Logan's Miss World events.

Miss World Pink Version Final, 1974
colour, 5min 43sec
notes 'Nov to March 73–74' on can. A shortened version of the previous film, shot through a pink gel.

In the Shadow of the Sun, 1972–74
colour, 49min 24sec
featuring: Karl Bowen, Christopher Hobbs, Gerald Incandela, Andrew Logan, Luciana Martinez, Kevin Whitney, Francis Wishhart, Graham Dowie
music: Hector Berlioz, *Grand Messe des Morts* (Op. 5)
notes: this film was blown up to 16mm (running at 54 min) and an original soundtrack by Throbbing Gristle added for a premiere at the Forum der Jungen Films, Berlin Film Festival, February 1981.

Fred Ashton Fashion Show, 1974
colour, 67min 55sec
notes: choreography by Sir Frederick Ashton, costumes by Michael Fish. A fundraiser for the Royal Ballet School.

Bill Gibb's Show, 1974
aka *Bill Gibb Show*
colour, 15min 50sec
notes: Bill Gibb's winter 74/75 collection filmed by Jarman.

Duggie Fields at Home, 1974
aka *Duggie Fields*
colour, 2min 50sec
featuring: Duggie Fields
music: inscribed on can: 'Marlene from P ... tape part 2'; compilation for ICA screening: Rolling Stones, 'You Can't Always Get What You Want'
notes: '1975, 9fps' on can.

Picnic at Rae's, 1974
aka *Lunch at Rae's*
colour, 9min 15sec
featuring: Rae Spencer-Cullen, Gaby Chautin, Duggie Fields, Andrew Logan, Jenny Runacre
music: Joseph Canteloube, *Chants d 'Auvergne*
notes: '3fps, 1975' on can.

Here We Are, 1974
aka *Here We Are at Sloane Square dec 74*
colour, 3min 46sec
notes: end title card reads: 'Goodbye till next year Derek'. A time-lapse film similar to *Sloane Square* but with a lot shot at night.

Herbert in NYC, 1974
aka *New York Walk Don't Walk*
colour, 26min 5sec
featuring: Herbert Muschamp
music: Lou Reed, 'Walk on the Wild Side'

NYC, 1974
aka *New York City*
b&w, 3min 28sec
notes: 'NYC 1972' on can. A series of shots of window dummies intercut with New York women filmed on the street.

Dinner and Diner, 1974
aka *Dinner at the Diner with Bart and Reggie New York 1974*
b&w, 10min 23sec
notes: filmed at the Market Diner, 9th Avenue and West 33rd Street, an old chromed dining car. There is a fault that recurs throughout the film, not unlike the one in *The Devils at the Elgin* (below), manifesting as a solarization of the image.

284

Sister Jean of the Angels, 1974
b&w, 25min 59sec
notes: '*summer 74*' on can. It appears to be shot footage (rushes) from a screening of Ken Russell's *The Devils*, for which Derek designed the set, at the Elgin cinema, which was later refilmed as *The Devils at the Elgin*.

The Devils at the Elgin, 1974
aka ***Jean des Anges; Reworking the Devils***
b&w, 14min 55sec
notes: the finished film, consisting of key moments and all the main shots featuring Derek's set design in the film.

Fire Island, 1974
colour, 28min 45sec
notes: '*1973*' on can.

My Very Beautiful Movie, 1974
colour, 17min 13sec
notes: '*first version Aug–Nov 74*' on can. The main difference between this and the previous film is that a lot of dirt accumulated in the gate of the first version (since it is a superimposition, the image of the dirt remains) but is missing in the second.

The Kingdom of Outremer, 1974
colour, 13min 2sec
notes: '*October 74*' on can.

A Garden, 1974
colour, 32min 3sec
featuring: Kevin Whitney, Luciana Martinez
notes: '*August 72–May 74*' on can. Filmed through a red filter.

Corfe Film, 1975
aka ***Troubadour Film***
colour, 70min 56sec
featuring: Paul Humfress, Luciana Martinez
costumes: Christopher Hobbs
notes: '*July 1972 Worth Matravers: Andrew Logan is to play the silver masked god. Christopher Hobbs has constructed the mask of genius.*' (Derek Jarman, *Dancing Ledge*).

Ken Hicks, 1975
colour, 9min 28sec
featuring: Ken Hicks
notes: Ken Hicks demonstrates the correct use of an antique roman strigil.

Sebastian Wrap, 1975
aka ***Mirrors; A Break from Sebastian; Sebastian Mirror Film***
colour, 5min 58sec
featuring: Guy Ford and members of the cast of *Sebastiane*
notes: this film was blown up to 16mm in 1981 and an original soundtrack by PTV (called 'Mirrors') added.

Karl at Home, 1975
b&w, 17min 44sec
featuring: Karl Bowen

Breakfast at Swanage, 1975
colour, 17min 7sec
notes: this film follows *Karl at Home* on the same reel.

Gerald's Film, 1975
colour, 17min 28sec
featuring: Gerald Incandela
music: Gustav Mahler, *Symphony No. 5*, 4th movement
notes: 3fps on can.

Sloane Square: A Room of One's Own, 1974–76
aka ***Removal Party; Sloane Square***
colour and b&w, 8min 19sec
filmed by: Derek Jarman, Guy Ford
featuring: Guy Ford, Alasdair McGaw, Graham Cracker, Derek Jarman
music: Kraftwerk, 'Robots'
notes: this film was blown up to 16mm in 1981 with a running time of 11 minutes and an original soundtrack by Simon Fisher Turner was added.

Sex Pistols in Concert, 1976
b&w, not digitized
location: Andrew Logan's studio
notes: used in *The Great Rock 'n' Roll Swindle* and *The Filth and the Fury* (dir. Julien Temple).

Ulla's Fete, 1976
aka ***Ulla's Chandelier***
b&w, 8min 54sec
featuring: Andrew Logan, Ulla Larson-Styles, Duggie Fields, Little Nell, Rae Spencer-Cullen, Janet Street-Porter, Liliana Cavani, Kevin Whitney, Marc Bolan
music: Mike Oldfield, *Tubular Bells*; on the ICA compilation: unidentified Russian song
notes: '*1974, 3fps*' on can.

Houston Texas, 1976
b&w, 34sec
notes: a fragment showing the unwrapping of artworks for an exhibition in Houston.

The Sea of Storms, 1976
aka ***Kingdom***
b&w, 17min 13sec
notes: '*Nov 76*' on can.

Jordan's Dance, 1977
colour, 16min 29sec
featuring: Jordan, Steve Treatment, Jean-Marc Prouveur, Howard Malin
notes: sections from this film are included in *Jubilee*.

Jordan's Jubilee Mask, 1977
aka ***Jean-Marc Makes a Mask***
b&w, 10min
featuring: Jean-Marc Prouveur, Jordan, Jenny Runacre

Art & the Pose, 1977
aka ***Arty the Pose***
b&w, 8min 11sec
featuring: Jean-Marc Prouveur, Gerald Incandela
music: Maurice Ravel, *Piano Concerto in G major* (M. 83)
notes: this was later blown up to 16mm and included in the portmanteau film *The Dream Machine*, 1986.

Every Woman for Herself and All for Art, 1978
b&w, 1min 57sec
featuring: Jordan, Venus di Milo
notes: this was blown up to 16mm in 1981 and a soundtrack of bees added.

***Italian Interlude,* 1978**
colour, 16min 58sec
composed of four fragments:
1. 'The Fountain', 1978
2. 'The Pantheon', 1978
3. 'Italian Street Scene', 1978
4. 'Italian Ruins', 1978
music: ICA compilation: Shostakovich, *Cello Concerto No. 1* (Op. 107)
location: Rome
notes: 'The Pantheon' features in *The Angelic Conversation*, projected over Steve Radnor.

***T.G.: Psychic Rally in Heaven,* 1981**
aka ***Psychic Rally in Heaven***
colour, 07min 27sec
featuring: Throbbing Gristle in concert
location: Heaven nightclub, London
notes: this film was immediately blown up to 16mm, and music from Throbbing Gristle's album *2nd Annual Report* added as a soundtrack.

***Jordan's Wedding,* 1981**
colour, 4min 53sec
featuring: Jordan, Kevin Mooney and wedding guests
music: The Kinks, 'Big Black Smoke', 'Waterloo Sunset' and 'Fancy'; The Small Faces, 'Itchycoo Park'

***B2 Movie,* 1981**
colour and b&w, 29min 58sec
featuring: Dave Baby, Judy Blame, Howard Brookner, Graham Cracker, Keith Hodiak, Hussain, Gerald Incandela, Jordan, Alasdair McGaw, James Mackay, Andy Marshall, Padeluun, Scarlett, John Scarlett-Davies, Volker Stokes, Jean-Marc Prouveur
music: Bessie Smith, Hoagie Carmichael and others (Dave Baby provided a soundtrack for the film made up from his father's collection of classic tracks)
notes: 'December 1981' on can (but filmed over the whole of 1981).

***Steve and Mark,* 1982 (?)**
colour, 15min 2sec
location: the first part is filmed on a platform at a Hovercraft terminal. The second part was filmed in Phoenix House, London.

***Rake's Progress,* 1982**
colour, 22min 46sec
featuring: Ken Russell and the cast of *The Rake's Progress* (Stravinsky), Maggio Musicale Fiorentino, Teatro Communale production
location: Teatro della Pergola, Florence

***Pontormo and Punks at Santa Croce,* 1982**
colour, 9min 16sec
notes: '2nd May' on can.

***Waiting for Waiting for Godot,* 1982**
colour, 7min 14sec
featuring: Sean Bean, Gerard McArthur, John Maybury, Johnny Phillips
location: RADA student performance of Samuel Beckett's *Waiting for Godot*
notes: 'RADA, Gerard McArthur, Oct 82, mute' on can.

***Pirate Tape,* 1982**
aka ***WSB Pirate Tape***
colour, 9min 58sec
featuring: William Burroughs, Peter Christopherson, James Grauerholz, Tim Burke
music: original soundtrack by PTV
notes: transferred to 1" video and telerecorded onto 16mm.

***ICA,* 1982**
aka ***Working for Pleasure***
b&w, 75min 4sec
featuring: Christine Bennie, Judy Blame, Ken Butler, Michael Clarke, Andy Marshall and others
location: Derek's 1982 ICA show.

***Ken's First Film,* 1982**
colour, 9min 54sec
filmed by: Ken Butler
featuring: Derek Jarman

***Diese Machine ist Mein Antihumanistiches Kunstwerk,* 1982**
b&w, 5min 4sec
notes: based on an artwork by Padeluun.

***It Happened by Chance,* 1972–83**
It Happened by Chance is the name given to twelve reels of fragments and diary films compiled between 1972 and 1983. By their very nature these cut-ups are not strictly chronological. The date listed is an indication of when each was compiled rather than when the component parts were filmed.
The film cans bear the following dates:
Vol. 1: '72'
Vol. 2: '73'
Vol. 3: '74'
Vol. 4: '75'
Vol. 5: '76'
Vol. 6: '77'
Vol. 7: 'Nov 79'
Vol. 8: 'Dec 80'
Vol. 9: '81'
Vol. 10: 'Apr 83'
Vol. 11: 'Apr 83'
Vol. 12: 'Apr 83'

Since these films were shown at different speeds at different times, it would not be useful to provide running times here. As an indication, a speed of 6 frames per second would give each a running time of between 40 and 60 minutes.

***The Dong with the Luminous Nose,* 1983**
aka ***Home Movie Dong***
colour, unfinished
filmed by: Derek Jarman, John Maybury
featuring: Ken Campbell and others
location: Chesil Beach, Dorset
notes: an unfinished Super 8 of Edward Lear's poem of the same name.

***Barcelona Man,* 1984**
colour and b&w, 20min
featuring: Genesis P-Orridge
location: Barcelona
notes: rushes for a promotional film for PTV.

***Glitterbug,* 1994**
colour, 60min
35mm
notes: a BBC *Arena* special drawn from Super 8mm films shot between 1972 and 1983.

INDEX

Page numbers in *italic* refer to illustrations.

Andrew Logan Kisses the Glitterati 68–69
Angelic Conversation, The 18, 35, *35*, 235
Anger, Kenneth 25, 145
Antoniszczak, Julian Jósek 49
Art & the Pose 32, *196–201*
Art of Mirrors, The 13, 27, *35*, 278
Ashden's Walk on Møn 16, 30, *122–27*
At Low Tide 25, 31, *42–47*
Avebury 26, 29, *112*, 113, *116–21*

B2 Movie 19, 32, *38*, *82*, *202–15*
Baillie, Bruce 25
Balance, Jhon 26
Balch, Anthony 34
Beckett, Samuel 34, 216
Bernstock, Paul 233
Blixen, Karen 34, *70–73*
Blue 18, 143
Burning the Pyramid 19, 24
Burroughs, William S. 32, 34, 220
Butler's Wharf 26, 27, 32, 98

Caravaggio 50, 234, 235
Chivers, Stephen 234
Cocteau, Jean 25, 235
Corfe Film 28, 31, *162–71*
Crowley, Aleister 145

Dawson, David 32
Death Dance 98–103
Dee, John 189, 234
Deller, Gunter 276
Duggie Fields at Home 31, *128–33*
Dorset 25, 31, *42–47*
Du Cane, John 26

Edward II 17, 84
Egypt 30
Electric Fairy 25
Elgin Cinema, The 29
Essex *184–87*

Fields, Duggie 31, *128–33*
Finch, Nigel 18
Fire Island *12*, *134–41*
Fire Island 24
Ford, Guy 31

Garden of Luxor 30, *86–97*
Garden, The 35, 276
Gerald's Film 24, 31, 85, 175, *177*, *184–87*
Giannaris, Constantine 234
Gidal, Peter 15, 234
Giorno, John 32
Gysin, Brion 32, 34

Harwood, Anthony 31, 70
Heuwinkel, Christiane 144
Hicks, Ken 31
Hobbs, Christopher 26, 27, 30, 31, 42, 98
Hoffmann, Maja 13, 275, 276
Hobbs, Christopher 74

I'm Ready for my Close-Up 26
ICA 24, *223–31*
Imagining October 18, *34*, 35, 85
In the Shadow of the Sun 14, 16, 22, 27–29, *30*, 104, *142*, 144, 146, *148–53*, 274, 280
Incandela, Gerald 26, 27, 32, 70, 184, 196
It Happened by Chance 14, 19, 34, *36–37*, *232*, 236, *237*, *238–72*, 274, 278

Jordan's Dance 32, *188*, 189, *192–95*, 233
Journey to Avebury, A 26, 27, 28, 30, *112*, 113, *116–21*, 277
Jubilee 17, 31, 32, 84, 189
Julien, Isaac 13, 14, 83, *233–36*, 275

Keen, Jeff 16
Ken Hicks 31, 32

Lahire, Sandra 234
Last of England, The 18, 35, 234, 276, 279
Latham, John 16
Le Grice, Malcolm 15, 234
Logan, Andrew 25, 26, 27, *30*, 34, 42, 68–69

MacCabe, Colin 236
Mackay, James 13, *14–19*, *22–35*, 235, 236, *274–76*
Magician, The 28
Martinez, Luciana 27, *30*, 31, *162–71*
Matthee, Jean 234
Maybury, John 234
Middleton, Peter 32
Møn, island of 30
Muir, Gregor 50, 235
Mulvey, Laura 83
My Very Beautiful Movie 12, 27, *134–41*, 277

Niépce, Nicéphore 145

O'Pray, Michael 143, 274

Peake, Tony 236
Picnic at Rae's 24
Pirate Tape 32, *220–23*
Prouveur, Jean-Marc 32, 196

Rahms, Dieter 23
Red Movie 26
Reynolds, Paul *35*
Rhodes, Liz 15
Roth, Dieter 14
Ruf, Beatrix 13, *14–19*
Russell, Ken 16, 144, 145
Russell, Tom *274–80*

Sandrich, Mark 190
Sebastian Wrap 31, 32, *172*, *173–75*, *178–83*
Sebastiane 17, 22, 30, 31, 32, 84, 175, 178, 233, 280
Sex Pistols, The 34
Sloane Square: A Room of One's Own 31, 85, *154–61*, 282
Smith, Jack 25
Somerville, Ian 32
Stolen Apples for Karen Blixen 34, *70–73*
Studio Bankside 26, 50, *52–67*
Sulphur 34, *104–11*, 280
Swinton, Tilda 236

T.G.: Psychic Rally in Heaven 83
Tarot 26, *74–81*, 233, 275
Tempest, The 17, 31, 233
Temple, Julien 34
Thew, Anna 234
Tillmanns, Wolfgang 50
Turner, Simon Fisher 31, 34, 282

Ulla's Fete 175–76

Waiting for Waiting for Godot 34, *216–19*
Welch, Elizabeth 233
Whitney, Kevin 27
Wollen, Peter 83
Wyn Evans, Cerith *24*, 234

ACKNOWLEDGMENTS & PICTURE CREDITS

For Derek

The author would like to thank:
Maja Hoffmann
Stanley F. Buchthal
Keith Collins
Tony Peake
Tom Russell
Anna von Brühl
Marie Valentino
Kevin Doogan
Gunter Deller
Ben McIlveen
Mike Cabble
Tristan de Lancey
Jon Crabb
Charlie Mounter

All the contributors

All the curators, festival directors, film programmers, film lovers who have supported and treasured Derek's Super 8 films over the years.

front cover
My Very Beautiful Movie (1974).

back cover
Frames from a selection of Super 8s.

page 1
Derek Jarman's 'Modern Light' Super 8 camera (a Nizo 560).

page 2
The Union Flag in flames during Jordan's Dance (1977).

pages 4–5
Jean-Marc Prouveur in a curtain and shadow episode from It Happened by Chance (1972–1983).

pages 6–7
Frames, filmed at Avebury, from It Happened by Chance (1972–1983).

pages 8–9
Two superimposition sequences from In the Shadow of the Sun (1972–74).

page 10
Jarman films his reflection in a mirrored sphere in B2 Movie (1981).

page 281
Derek Jarman glimpsed in an art deco teapot in Studio Bankside (1972).

First published in the United Kingdom in 2014 by Thames & Hudson Ltd, 181A High Holborn, London WC1V 7QX

Derek Jarman Super 8
© 2014 Thames & Hudson Ltd, London

Original text © 2014 James Mackay and Thames & Hudson Ltd, London

Extract on pp. 28–30 taken from *Dancing Ledge*, reproduced by kind permission of the Estate of Derek Jarman.

All film frames, unless otherwise stated © 2014 LUMA Foundation

Additional images:
1, 15(l), 15(r) Courtesy of Keith Collins
19 Courtesy of the author
16, 23(l), 23(r), 28, 35 Courtesy of BFI
27 Courtesy of Northampton Museums & Art Gallery
33 © the Estate of Derek Jarman.
Courtesy of the author
34 Courtesy of Basilisk Communications

All Rights Reserved. No part of this publication may be reproduced or transmitted in any form or by any means, electronic or mechanical, including photocopy, recording or any other information storage and retrieval system, without prior permission in writing from the publisher.

British Library Cataloguing-in-Publication Data
A catalogue record for this book is available from the British Library

ISBN 978-0-500-51732-1

Printed and bound in China by Everbest Printing Co. Ltd

To find out about all our publications, please visit **www.thamesandhudson.com**. There you can subscribe to our e-newsletter, browse or download our current catalogue, and buy any titles that are in print.